VINTAGE LONDON

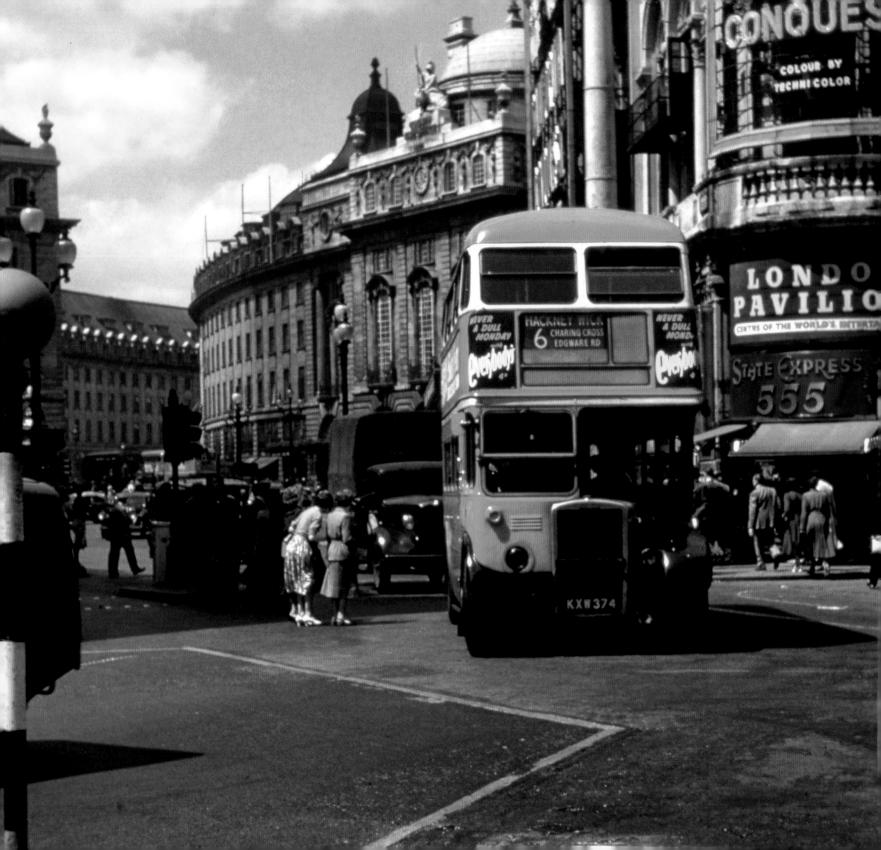

VINTAGE LONDON

THE CAPITAL IN COLOUR 1910–60

GAVIN WHITELAW

To my father, Ronald Whitelaw, 1928–2014, who
helped me more then he ever knew.

First published 2014

The History Press
The Mill, Brimscombe Port
Stroud, Gloucestershire, GL5 2QG
www.thehistorypress.co.uk

British Library Cataloguing in Publication Data.
A catalogue record for this book is available from the British
Library.

ISBN 978 0 7509 5208 8

Typesetting and origination by The History Press
Printed in India

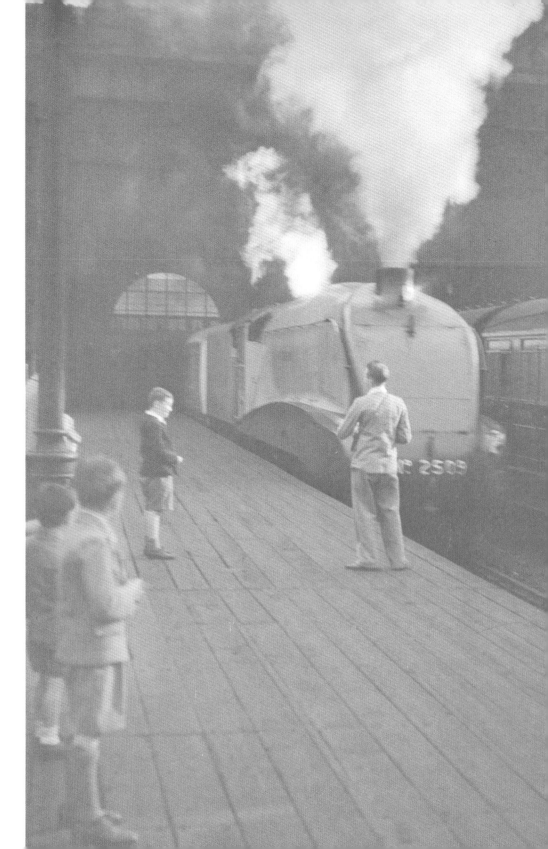

INTRODUCTION

'When it's three o'clock in New York, it's still 1938 in London.'

Bette Midler

This is a book where it *is* still 1938 in London in some of the images. It is earlier in a few, and in others it may be as late as 1960. The streets and scenes here are pictured as those at the time saw them, not in the monochrome shades so familiar now as we normally view the past. This book covers half a century of change in London, from the years immediately after King Edward VII's death in 1910 through to the early years of the reign of Queen Elizabeth II.

Colour photography has been available for over a century but for various reasons the general assumption is that it is a relatively modern development. As we view the images of the past that we normally see in shades of black and white, it is all too easy to forget that London, as seen by our parents and grandparents, was a colourful world. Certainly there are postcard views that purport to be colour views of London from the Victorian and Edwardian era, but these are largely artists' coloured interpretations of black and white views. All the images in this book are genuine colour images taken at the time by various processes that were available to the photographer. Victorian London, as far as I am aware, was not captured on film in colour. The very earliest images in this book were taken before the First World War, but these are amazingly rare and in almost twenty years or so of collecting photographs these are the only ones of London that I have found.

Early colour film, until the introduction of Kodachrome film in the mid-1930s was a rather grainy, low-resolution medium compared to some of the pin-sharp black and white images of the same period. This was due to the need to capture the three primary colours instead of only variations of light and dark as in monochrome photography. The images thus formed were grainier than the colour images we have come to expect today and required longer exposure times. Please bear this in mind when viewing the earliest colour images in this book. Some are not of great technical quality, but until anything better turns up (and the odds are very much against that) these are the only views of London in colour from the reign of George V that are available. These are views of a London that has not been seen for over eighty years.

The first widely available colour film from 1907 was the Autochrome, manufactured by the Lumiere Company, taken using glass plates covered with flattened and dyed potato starch grains. These were expensive and awkward to use. Other processes used black and white glass plates with taking and viewing screens that 'converted' the monochrome image into a colour one. However, it was not until colour film on a celluloid base was marketed in the mid-1930s that colour photography became more easily available to the amateur.

By the 1930s, when celluloid-based films became available, glass started to become obsolete for most amateur usage. The two most popular films were Dufaycolor, which was first marketed in 1934, and Kodachrome in 1935. While Dufaycolor, which had been acquired by Ilford, was to succumb to advances in the 1950s with faster films becoming available, Kodachrome would last, with improvements, until 2009.

However, being available and being affordable are two entirely different things and colour film was extremely expensive – even black and white photography was not as common as it would be later in the century. In the 1930s when celluloid colour film became available, the Depression was in full flow and money was in short supply for a large percentage of the population – which goes some way to explaining the scarcity of 1930s colour photography. Even by the 1950s a 36-exposure roll of Kodachrome cost the equivalent in today's currency of around £50. If you take these reasons, add on the sixty or so years of house clearances when a lot of photographs must have been thrown out, damage from ill storage, damp, dust and fungal attack, it is not surprising that so few early images survive today; perhaps even in the 1930s not that many were taken to begin with!

After the Second World War exporting production to earn much needed funds to repay the war debt restricted the availability of certain luxury, and not so luxury, products as rationing was still in progress. Whilst difficult, but not impossible, to obtain in Britain, colour film was widely available in America and several British photographers asked American friends to bring colour film over when they visited. Only a very few British photographers 'wasted' colour film on street scenes because these would always be there, wouldn't they? Well, actually no, they wouldn't, things would have changed, almost imperceptibly. Mr Jones perhaps had a new car, the greengrocer or newsagent had retired and the shop was now renamed and repainted. Over the days, months and years the streets changed and it is only by viewing historic colour images that we can see how the streets actually looked all those years ago.

It was not only the streets and cars that were different. The colour palette of the streets was different too. You will see in these images muted and drab browns and greys, greens and blues that are as unfamiliar today as the vintage vehicles seen on these streets long ago. With the explosion of reds, yellows and fluorescents that scream warnings at our eyes and advertise their wares on our high streets today, the streets of fifty or more years ago seem so much easier on the eye. The colours of the street were more understated then and the road signs less garish.

Tourists brought colour film but the images went back to America with them. The London that tourists see has always been a mixture of the old and new. The pageantry mixing with the city carrying out its daily business as it has done for hundreds of years. For a tourist coming from America the history that was on show was one of the reasons for coming to London. America has relatively few really old buildings and, in cities like New York, very little that is even over a century old. To show people back home what you had seen on vacation, a city with some buildings nearly a thousand years old needed a camera, with colour film. Black and white images really would not cut the mustard.

The images you will see in this book are largely, but not totally, thanks to Americans visiting and having the foresight to bring Kodachrome film with them. The fact that it *always* seems to be sunny is a result of the slow speed of the film and the need for strong sunlight for a decent exposure. Occasionally, just occasionally, the camera came out in inclement weather so you get a flavour of what London was like in the grey, grim light of an overcast or rainy day. The quality

of some of the images is perhaps not what you would expect from a modern camera, but due to the age and rarity they have been included.

Since all these images were taken the streets of London have changed almost out of recognition and some of the views are impossible today due to urban development. If one could be transported back in time one would find things very different, the cars and vehicles, the clothes and the shops have, over the past six decades since the last images in this book were taken, metamorphosed into sterile clones of each other. We used to be a nation of individual shopkeepers, but now mostly seem to be chains of multinationals. In the first half of the twentieth century you would also need a different currency as this was a London of pounds, shillings and pence. White fivers – if you were lucky – more likely a 10s note, 12d to the shilling, silver sixpences, large copper pennies, half pennies and farthings. It was also a London with a King Emperor as monarch, the centre of an Empire but an Empire that was crumbling and would not last for the century.

The first thirty years of the twentieth century are now almost past living memory, so the very earliest images in this book will be unfamiliar. Even the 1950s images of the London that parents and grandparents knew may perhaps be a revelation when seen not in black and white but in colour. It is often the background details that prove the more interesting points of a photograph and not what is happening in the obvious foreground, which in most cases can be very familiar. Take a little time to immerse yourself in the past as even in the more mundane images the background can have a lot to offer!

Whilst this book was being compiled, two collections of images became available that illustrate two periods of London's history: one was thought to be ill represented photographically and for the other it was assumed that only a handful of images even existed. Up until mid-2013 it was thought that there were almost no colour images of London streets taken in the 1920s. A few Autochromes had been taken by the likes of Albert Kahn's Archives of the Planet and the National Geographic photographers, but only a very few. Autochrome was a very slow film, expensive and, by and large, confined Autochromists to portraits, indoor shots, flowers, gardens and the like – the colourful things that would impress guests at your magic lantern show. Fast-moving subjects such as traffic would be a problem and I only had one image of London on Autochrome: a poor, grainy, small stereo image of the Albert Memorial from 1932.

However, an important large collection of Autochromes that included a number of London street scenes in colour from the 1920s was obtained and a few are included in this book.

London immediately after the Second World War was notoriously camera shy. Travel from the United States to Europe was severely curtailed due to transport and logistical difficulties and you had to prove to the State Department that your trip was of benefit before permission would be granted. As a result, the late 1940s in colour are poorly represented photographically – no tourists! Fortuitously for this book, a collection of Dufaycolor transparencies have surfaced and I now have several images that were taken in 1946 showing a London ravaged by years of war. The scenes of devastation seem almost unbelievable now when every spare scrap of land seems to have been developed. The bleakness of post-war London is difficult to imagine after nearly sixty-five years of redevelopment has removed almost all signs of the bomb sites that littered the landscape.

Most of these images are unpublished. The railway images have been seen before but mainly in the specialised railway press, and this was before I acquired the collection of Cyril Perrier's father's Dufaycolors from the executor of his estate. Some of the others have appeared as small reproductions in a nostalgia magazine. The majority, however, are unseen in public before and I am eternally grateful for all the unknown photographers that took the time and effort to capture London on film, and in colour, when it was incredibly expensive to do so.

The smoke-blackened and war-ravaged London of so long ago is a far different place from the London of today. A further half-century of change has occurred since the latest of these fleeting glimpses was captured on glass and celluloid. This London has long gone and this book shows what the London of the past looked like as it was – and in colour. Immerse yourself in these images, the earliest not that far removed from a London that Dickens would have been familiar with. Just as this London has vanished, the London you see today will also pass as it is as ephemeral as the images you see in this book.

Right: Here on a Thames colour plate is the earliest colour image of London that I know of. It isn't the most exciting image, but captures a moment in 1910 as a potential theatregoer peruses the entertainments and a potential holiday destination on offer over a century ago.

Sarah Bernhardt was the most famous actress in the world at the turn of the twentieth century. Ninety years on from her death it is perhaps difficult to appreciate just how famous she was. In this Edwardian image taken in mid-1910, 'The Divine Sarah' is appearing at the Coliseum in the second act of *Laiglon*, a play by Edmond Rostand. The performance was recorded and her voice can be heard today on the acoustic recording. The Coliseum is still a theatre and is now the home of the English National Opera. At the Lyceum, *The Sins of London* by Walter Melville is playing as the autumn drama advertised with, compared to the Coliseum's wordy effort, an extravagantly illustrated poster.

Lupino Lane appears on the same bill as The Divine Sarah and, at 18, this was one of his earliest appearances. He was a member of the famous Lupino theatrical family and had been on the stage for three years by this time. He was later to make the Lambeth Walk famous in the 1930s.

Blackpool by the turn of the twentieth century was a booming seaside resort. With foreign holidays for the masses decades in the future it was the place to go for fun and a good time. By 1881 Blackpool was well established as a holiday destination and it was only in the 1960s, half a century away in the future from this advertisement, that it went into decline. No byline on the poster is required here; the name of the town is enough.

An Edwardian gentleman is perusing the hoarding. Will he choose culture in the form of a play or is he contemplating a holiday in the North travelling from Euston by the London and North Western and the Lancashire and Yorkshire Railways? Perhaps you can just see his movements across the plate as he moves away to the right. This was a long exposure. Did he ever go to Blackpool or see Sarah Bernhardt on stage?

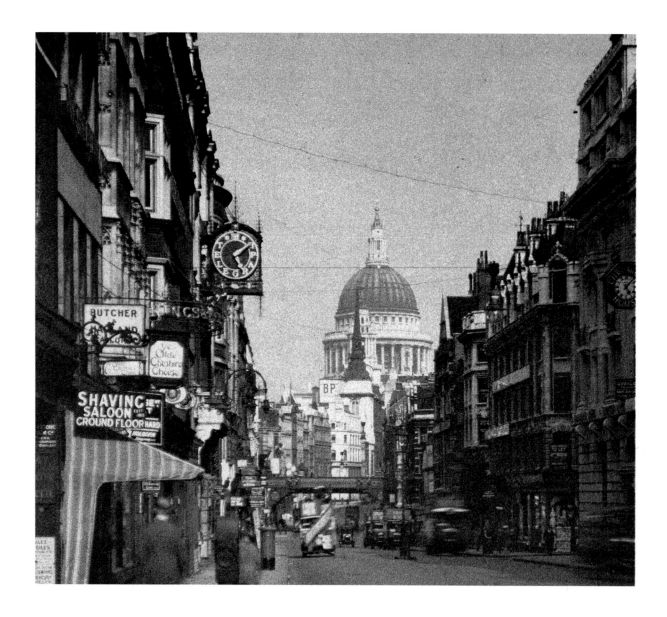

The great dome of St Paul's dominates the skyline in 1926 in this view as it has done since it was completed in 1708 with the final topping out of the lantern on top of the dome. The buses are more numerous and less camera shy in this image as one makes its way along Fleet Street with five coming the other way. What appears to be a taxi is heading towards the camera as well. No private cars seem to be in view for private car ownership was still the preserve of the very well-off. The *Telegraph* clock and the Chronicle House clock vie to tell the correct time and are almost the only visible clues to the newspaper publishing carried out in Fleet Street but, if you look very carefully in the left-hand corner of the image, the *Stamford Mercury* has offices, not as grand as the *Telegraph*'s, but on Fleet Street nevertheless.

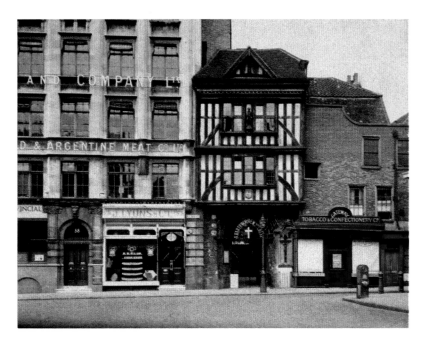

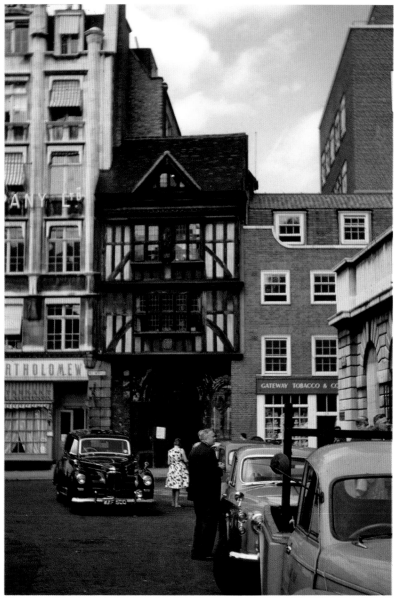

The gatehouse of the church of St Bartholomew the Great in West Smithfield survived the Great Fire of 1666. Seen here in 1926, it still had the Blitz ahead of it, another trial it would survive. The adjacent image of the same scene in 1959, thirty-three years later, provides an interesting comparison. In 1926, the Lyons tea shop, a slightly upmarket competitor of the ABC chain of tea rooms, discouraged tipping with a stern 'No Gratuities' on both doors. By 1959, however, the Lyons tea shop had metamorphosed into what appears to be the Bartholomew Restaurant. The Gateway Tobacco and Confectionery Company seems to have fared better, having had a revamp of the shopfront but on closer inspection the entire building looks to have been rebuilt in largely the same style as the 1926 image. A high-explosive bomb fell near here during the Blitz, which may account for the difference in the two buildings.

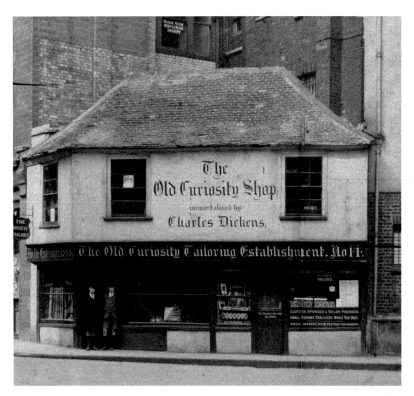

One of the problems with Autochromes is visible here in a 1926 image of The Old Curiosity Shop in Portsmouth Street. The glass has badly cracked and the resultant damage has discoloured the image. The image has been cleaned up as well as possible but the discolouration remains. Dating from around 1560, the shop predates the Great Fire by a century and is almost certainly one of the oldest surviving buildings in central London. It has had several businesses based in it over the years and is now a shoe shop, having for several years been an antique shop. Here, in 1926, it houses a tailoring establishment. Perhaps it was part of the inspiration for the Charles Dickens book of the same name; he lived near here and almost certainly was aware of the building. The painted name on its façade was added after the book was published.

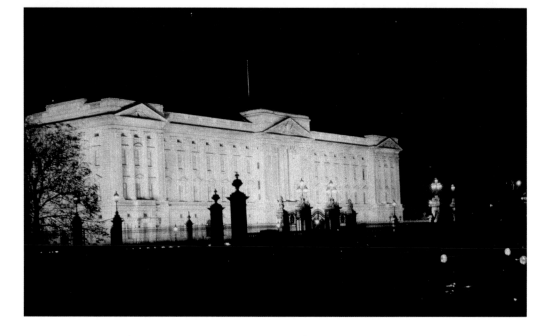

Buckingham Palace floodlit by night in 1931. Ambitious for an Autochrome plate, this scene has hardly changed over the years, although this may be one of the earliest images of the palace in colour at night. London then was a much darker city at night than nowadays and there is almost no extraneous light in the sky to detract from the majesty of the illuminated building.

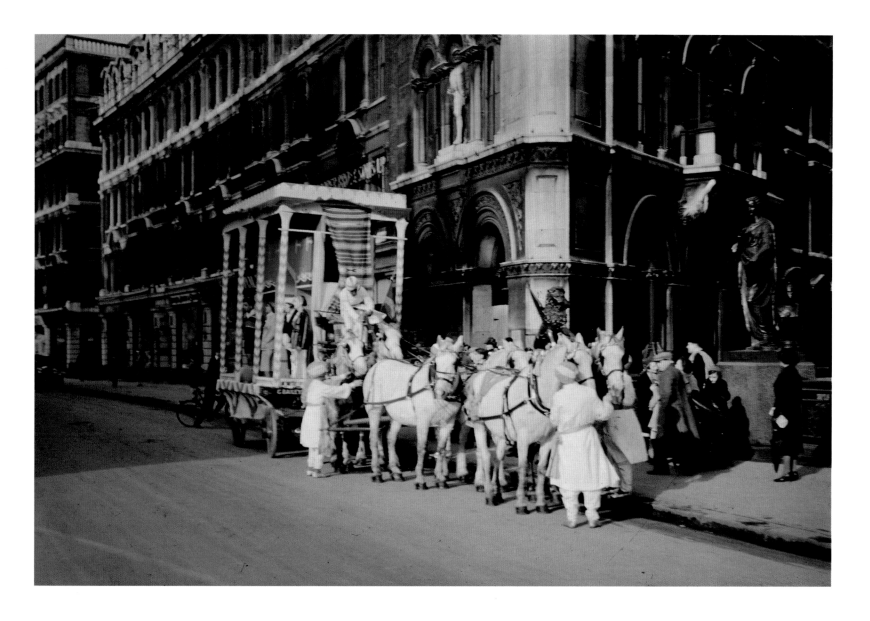

These two Dufaycolor transparencies of the 1937 Lord Mayor's Parade (the first to be televised) are from the camera of Sydney Perrier. The float in this image is 'India', on a horse-drawn dray from G. Bailey. India in this period, for good or ill, was still a part of the British Empire; a reminder that Britain not only had a King, but that he was also a King Emperor. The float is pictured on Holborn Viaduct, a road bridge built between 1863 and 1869. It was the first flyover in central London and replaced an earlier bridge that spanned the River Fleet (one of London's lost rivers and now entirely culverted, it can now only be seen as it flows into the Thames at Blackfriars Bridge). Only the building behind the float on the corner survives today.

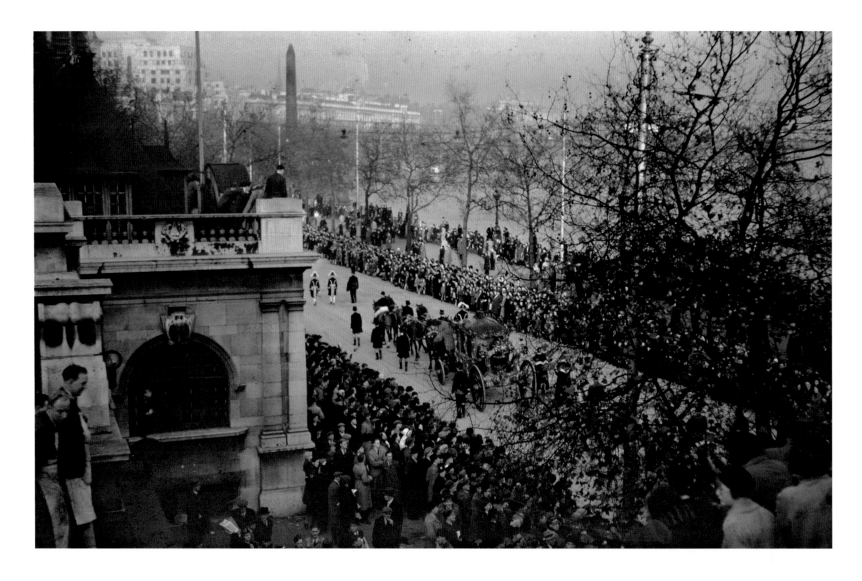

Up until 1711 the Lord Mayor had ridden a horse, but that year Sir Gilbert Heathcote had fallen off his horse and since then the Lord Mayor rode in a hired coach. This wasn't grand enough for the Lord Mayor-to-be of 1757 so Sir Charles Asgill persuaded the aldermen of the city to give money for a new grand state coach. This was built by Joseph Berry of Leather Lane, Holborn.

The Lord Mayor in 1937 was Sir Harry Twyford and he was the head of the textile company of George Brettle and Co., one of Britain's biggest hosiery companies, which had made vests for Nelson and silk stockings for George VI and Queen Victoria. He rode in the 1757 coach, which is still used today although it doesn't always complete the journey. Problems with the wheels necessitated forward travel by Land Rover from 2012; difficulties can occur when you are using one of the most intensively used eighteenth-century vehicles in the world!

VINTAGE LONDON

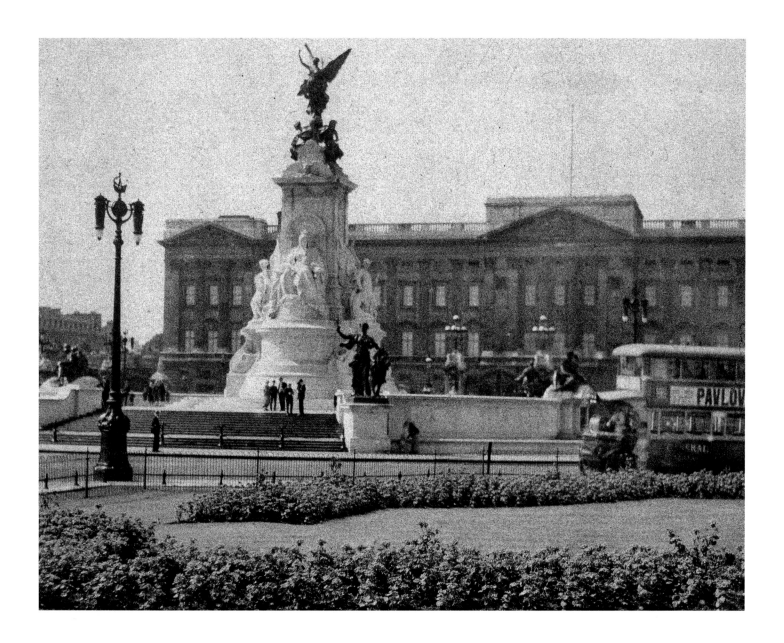

Buckingham Palace is seen here in 1926 on an Agfacolor plate. It is a scene that has changed little in the years since, although the General Bus company had only seven more years of independent existence before being swallowed up by London Transport in 1933. The advert on the side of the bus is not for a meringue-based desert, although that was named after her, but is for Anna Pavlova (1881–1931). She was the most celebrated dancer of her time, the role of the dying swan having been created for her in 1905, and had settled in London in 1912. She was the first ballerina to take ballet on a world tour. Her name lives on in the dessert after most have forgotten the amazing ballerina.

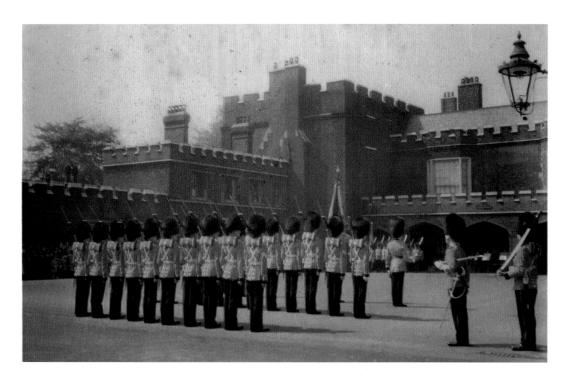

The Changing of the Guard is seen here at St James's Palace on 22 May 1938. The formation of guards will proceed to Buckingham Palace where the guards will change. This is amongst the 'must see' attractions in London for tourists. The ceremony begins at St James's Palace, still the official residence of the court, and proceeds to Buckingham Palace where the guards change. The ceremony, as it is seen here, has changed little since it was first carried out in 1837 when Queen Victoria had moved into Buckingham Palace, although the monarch had been guarded by detachments of guards from various regiments since 1660.

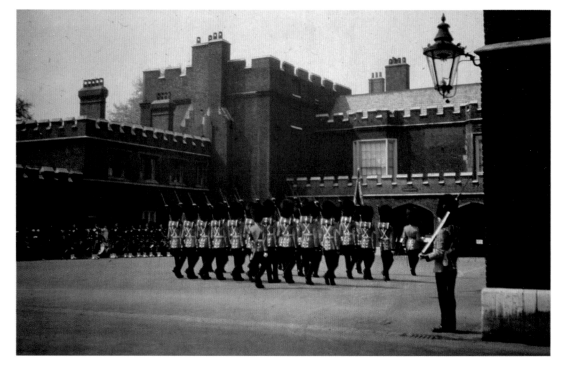

King's Cross station, 1 September 1937. A4 2509 Silver Link leaves on the Silver Jubilee to Newcastle, the London and North Eastern Railway's streamlined express introduced in 1935. This locomotive reached 112mph on its inaugural run. The stygian gloom of the station contrasts with the silver-grey livery of the train. The à la carte menu in the restaurant car would make your mouth water – lobster for 2s, fillet steak with chips for 2s 6d, a savoury omelette for 1s.

It is difficult to grasp the fervour of publicity that accompanied the introduction of the A4 class and the Silver Jubilee. With the standard LNER coach livery of varnished teak on the train adjacent to the A4, a passenger gazes out – even two years after it was introduced it was still *the* way to travel to Newcastle which was four hours away at an average speed of 67mph.

This service would cease with the outbreak of the Second World War and would never run again.

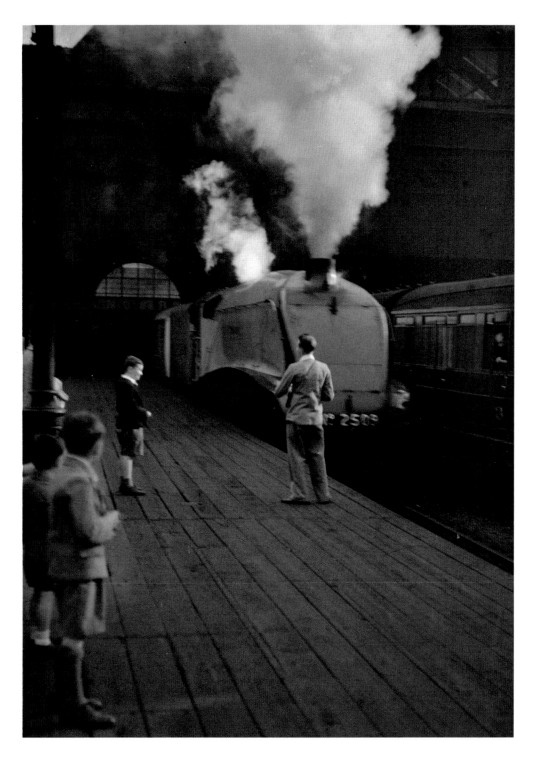

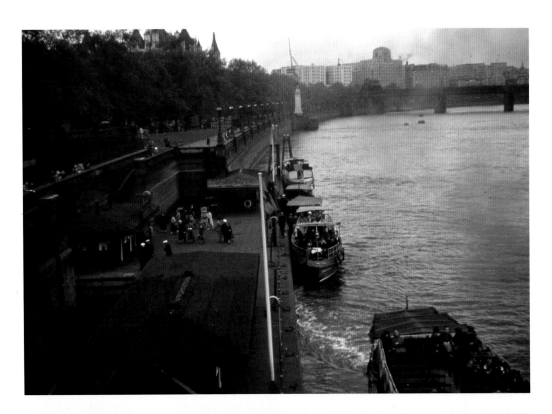

Pleasure steamers leaving Westminster Pier in 1936, taken on early Kodachrome film. Kodak had not quite got the chemistry right and these early Kodachromes fade badly. This one has been colour corrected.

For most of the twentieth century river traffic for passenger use was mainly pleasure trips. There was a brief dalliance from 1905–07, which was financially ruinous for the London County Council, and it was not until the Second World War that a temporary service was introduced using commandeered pleasure steamers to replace tram and rail services disrupted by the Blitz. After the war it was not until the turn of the millennium that regular commuter sailings recommenced.

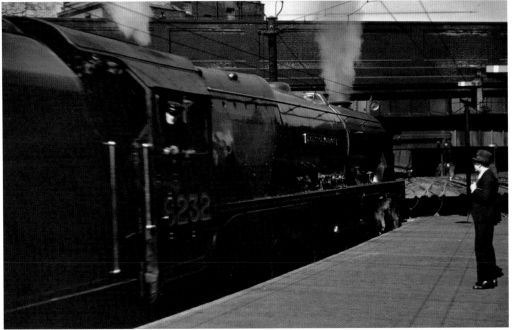

It was not only the LNER that introduced streamlined services and, here at Euston station in 1938, an almost brand new Duchess leaves for Glasgow on the Royal Scot. However, unlike the A4 class of the LNER, the LMS streamlined locomotives also came in conventional form. 6232 *Duchess of Montrose* is seen here, only a few months old, in April 1939. The lone onlooker is sporting a brown trilby. Headgear is seldom seen nowadays; it was almost de rigueur back then!

A London Transport District Line Underground unit is seen at East Ham en route to Barking on 8 May 1937. Few pre-war images exist of London Underground trains in colour. This was the only slide of the Underground that Sidney Perrier took.

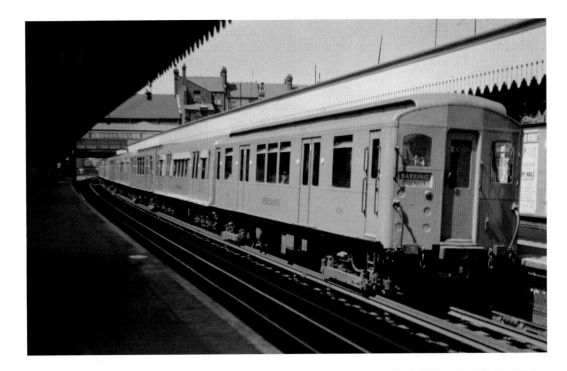

The enamel adverts that adorn King's Cross station exhort the reader to purchase Camp Coffee, Bovril and Stephens' Inks amongst other brands that are still familiar today. However, others have disappeared – Virol, the ubiquitous enamel sign beloved of preserved railway stations today, was a health preparation, based on bone marrow extract. The one advert that perhaps merits more attention than the others, and is surprising for the LNER advertising department allowing it, is for North Eastern Airways. They flew from London Heston Aerodrome to Edinburgh (Turnhouse) and Aberdeen, directly in competition with the LNER's own services. By 1939 they had been flying for four years. The A4 class locomotive is 4466 *Herring Gull* which would be renamed *Sir Ralph Wedgwood* after the original locomotive carrying that name was destroyed in an air raid at York in 1942.

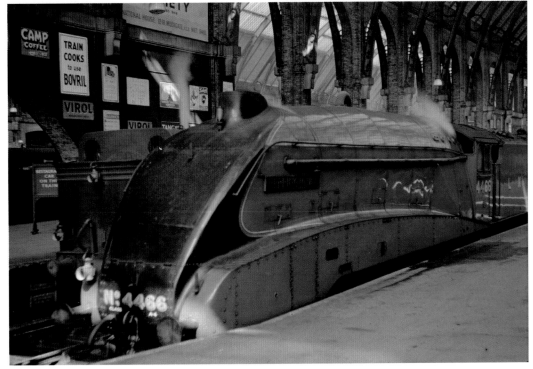

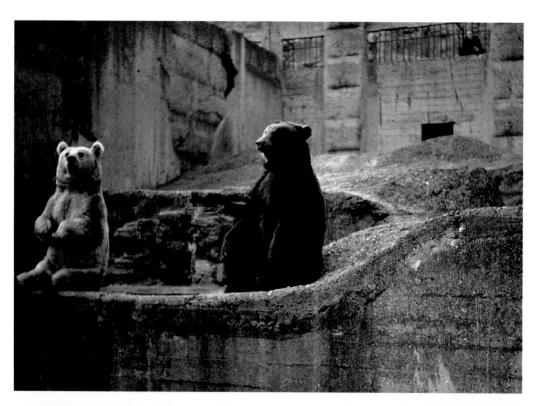

Among the most distinctive structures of London Zoo in Regents Park are the Mappin Terraces. Designed to imitate rock formations, it was opened in 1913 to display animals in as natural an environment as possible. There were six bear enclosures on the Mappin Terraces, seen here around 1937, housing various types of bears until the terraces were deemed unsuitable and closed in 1985. They have since been refurbished and opened up with wallabies and emus as an Australian outback landscape.

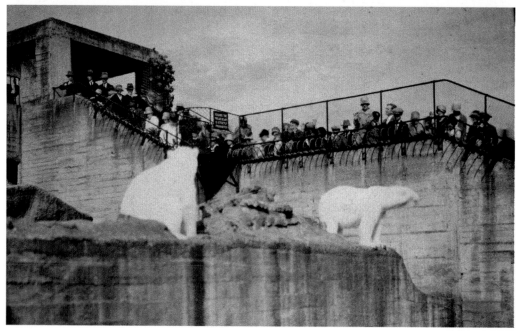

Until 1985 London Zoo had polar bears on display, seen here on the Mappin Terraces in 1926. Zoo conditions are not conducive to polar bear captivity and there are few now kept as the conditions induce repetitive behaviour in the bears due to boredom. The Mappin Terraces have now been redesigned and there are few indications now of the bear pits that were once housed here.

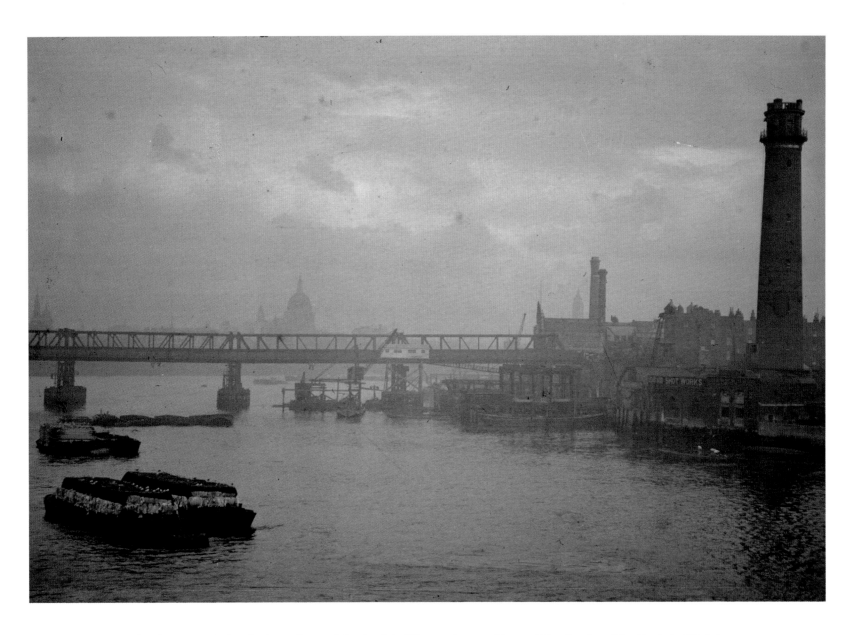

The Shot Tower in Lambeth on the south bank of the Thames: in 1951 this would be the site of the Festival of Britain but in this Dufaycolor transparency it is 1938 and it is still an industrial site. The tower was constructed in 1826 for Thomas Maltby & Co. In 1839, it was taken over by Walkers, Parker & Co. and they operated the tower until 1949. Molten lead was dropped internally and as it fell, it cooled and formed spheres of lead shot for ammunition. In 1950, the gallery chamber at the top of the tower was removed and a steel superstructure was added instead, providing a radio transmitter for the 1951 Festival of Britain.

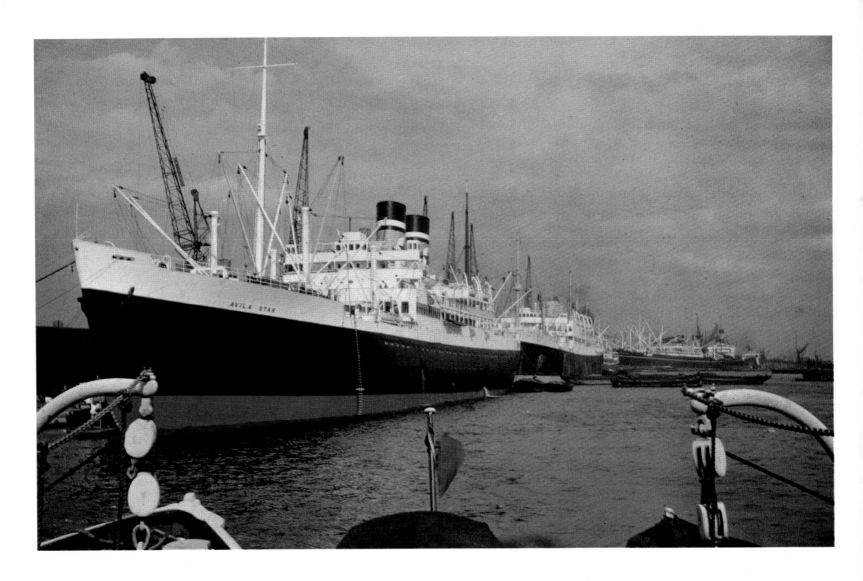

Above: London's Docks, receiving shipments from all corners of the world, were once the largest in the world. Overseen by the Port of London Authority, this image gives some idea of what it must have been like by the mid-1930s.

The ship pictured, the Blue Star Line's SS *Avila Star*, would become a war casualty. She was sunk by U-boat U-201 with the loss of eighty-four lives off the Azores on 6 July 1942 en route to Liverpool. She was carrying a cargo of frozen meat from Argentina.

Right: The entrance of St James's Palace in Cleveland Row is seen here in May 1938. As the palace is a working palace, although no monarch has resided here for over two centuries, apart from viewing the Changing of the Guard, it is not open to the public. The gatehouse seen here is one of the remaining parts of Henry VIII's original Tudor building.

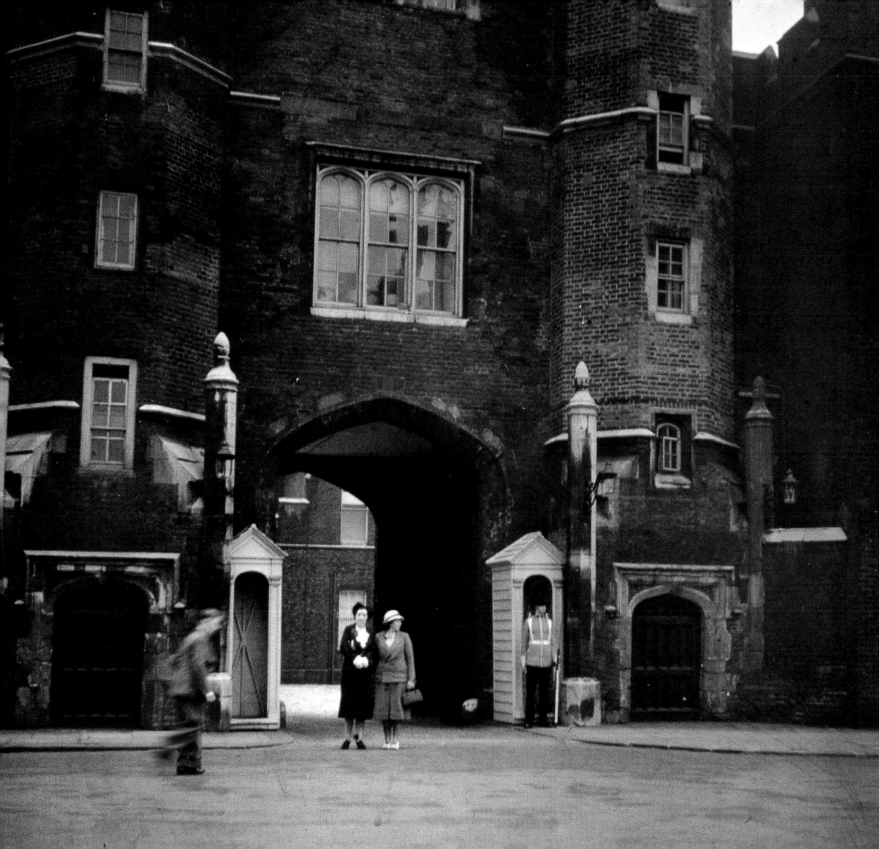

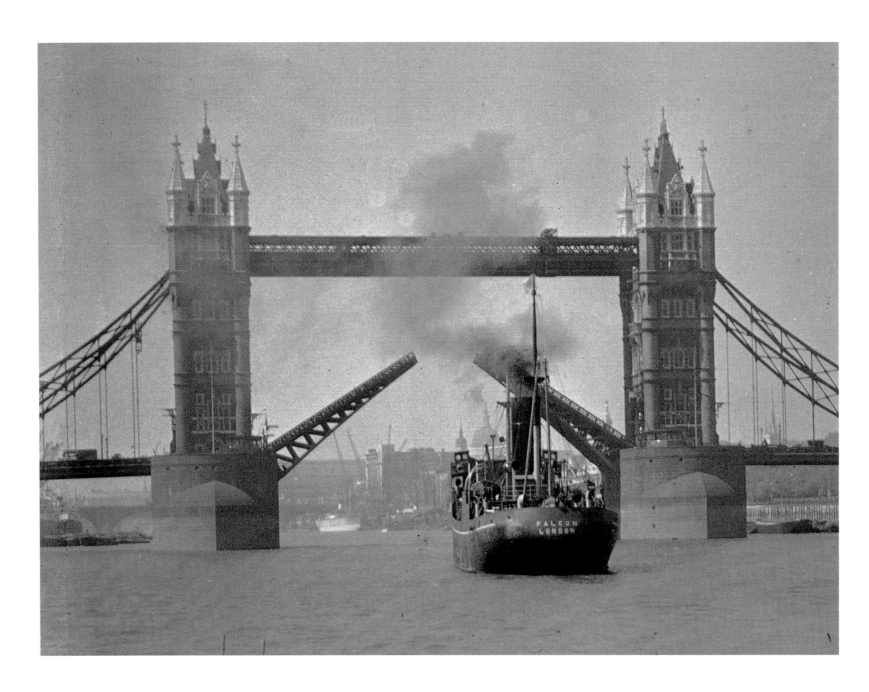

There are plenty of familiar images of London that are recognised all over the world. Perhaps one of the most famous is Tower Bridge. Opened in 1894, it was only 44 years old when the bascules opened here in 1938 to allow the SS *Falcon* of the General Steam Navigation Company to pass through into the Pool of London, then still a bustling port.

Trafalgar Square, another stop on the tourist trail through London, is seen here in another early Kodachrome transparency. What makes this image interesting is that the present fountains were only designed in 1939 by Sir Edwin Lutyens and this picture shows the original fountains. Trafalgar Square, familiar to generations of visitors to London, has undergone subtle changes over the years and several of its features may not be the accident of design that many think. The original purpose of the fountains was to break up the open space and prevent the formation of crowds which could lead to the potential risk of riots. This was not as far-fetched as it would seem as at the time that the square was opened, in 1844, the Chartist movement was seeking reforms in Parliament which included a vote for every man over 21, a secret ballot and payment for MPs among other demands, none of which seem outrageous today, but in the 1840s were viewed as radical.

The fountains we see today were finally opened in 1948, the old fountains being purchased by the National Art Collection Fund of Great Britain and presented to the cities of Ottawa and Regina in Canada where they remain in service. The present ones are memorials to two Admirals of the Fleet from the First World War, the western commemorating Lord Jellicoe (1859–1935) and the eastern Lord Beatty (1871–1936). They in fact outrank Lord Nelson, who was only ever a vice admiral (Vice Admiral of the White) and never actually a full admiral. Admirals and vice admirals were ranked according to the rank of their squadron – Red, White or Blue, with the Admiral of the Red being Admiral of the Fleet.

Throughout the years London has run various forms of public transport. Buses and Underground trains still remain and trams have returned to Croydon but trolleybuses are long forgotten. The last was withdrawn in 1962. Two are seen here at Woolwich at the Market Hill terminus on 15 March 1938.

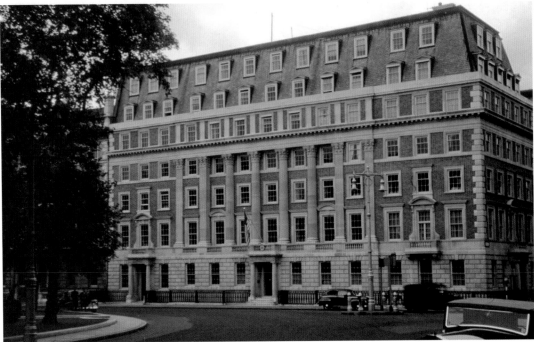

From 1938 and through to 1960 the American Embassy in London was situated in this building in Grosvenor Square. Serving only three presidents, Roosevelt, Truman and Eisenhower, it relocated in 1960 into a purpose-built building further round the square. During the Second World War Eisenhower's command was also on Grosvenor Square and it has had an American presence since John Adams established the first American mission to the Court of St James in 1785.

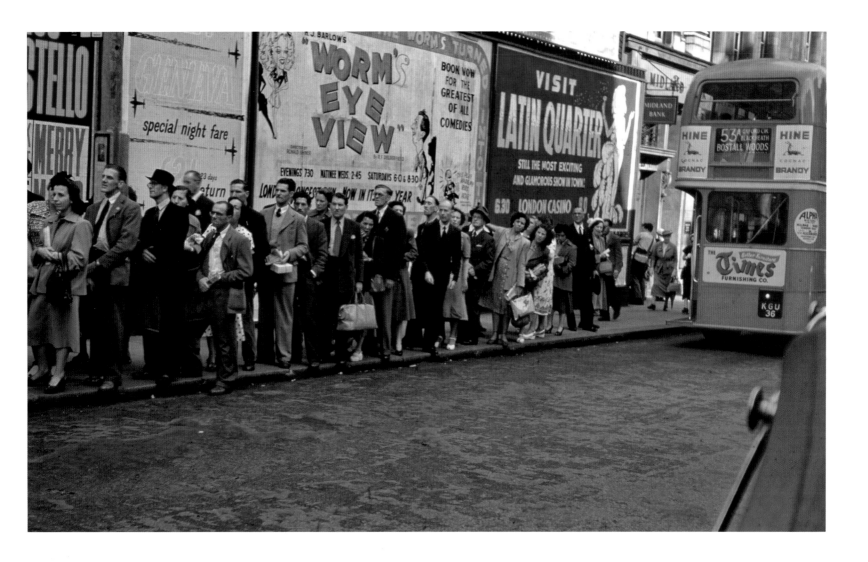

A shot of a bus queue and the rear of a London bus. At first it seems there is not much to see here, but actually there is a lot going on. There are clues to the date in the poster for *Worm's Eye View*. This ran at the Whitehall Theatre (now the Trafalgar Studios) for two runs, the first in 1945 and the second from 1947–51, totalling 1,745 performances. There is a poster advertising night flight fares to Geneva at £21 return, so this looks to be taken during the 1947–51 period, as flights to Geneva would be curtailed during and immediately after the war. *The Latin Quarter* – a variety show – was running at the London Casino (now the Prince Edward Theatre) on Old Compton Street in 1950–51 so that confirms the date as the very early 1950s. The bus queue seems to be straining to see the next bus to arrive and the hoarding that has supplied all the clues is probably covering a bomb site from the war that finished over five years before. The 53A bus route still runs but as route 53 now.

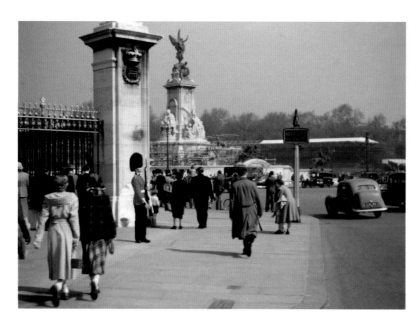

In 1953 London celebrated the Coronation of Queen Elizabeth II. The eyes of the world would be on London so it had to look its best, and the people coming had to be able to see the celebrations. Rows and rows of grandstands were constructed to accommodate the crowds and here they are seen near Buckingham Palace behind the Victoria Memorial. Buckingham Palace is to the left behind the railings and the view is looking towards The Mall. London is recovering from years of war and austerity and this would have been a welcome blast of colour in a drab post-war world.

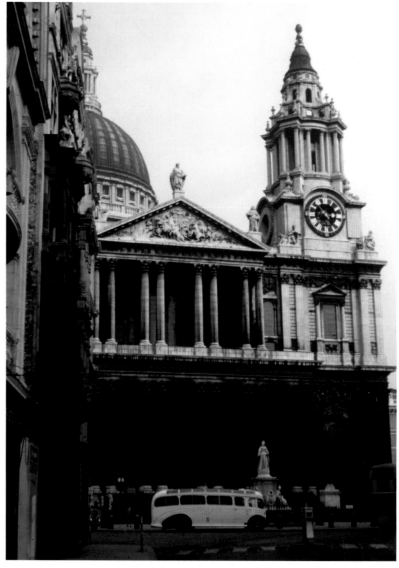

St Paul's Cathedral, until 1962 the tallest building in London, stands sentinel over Ludgate Hill. The smoke-blackened buildings on the left would be demolished in a few years' time, having survived the Blitz. The coach looks to have possibly parked to allow its passengers to visit the cathedral, something you could not do today without incurring the wrath of parking attendants. However, it would be 1960 before the first traffic wardens would be introduced so that won't be a problem here.

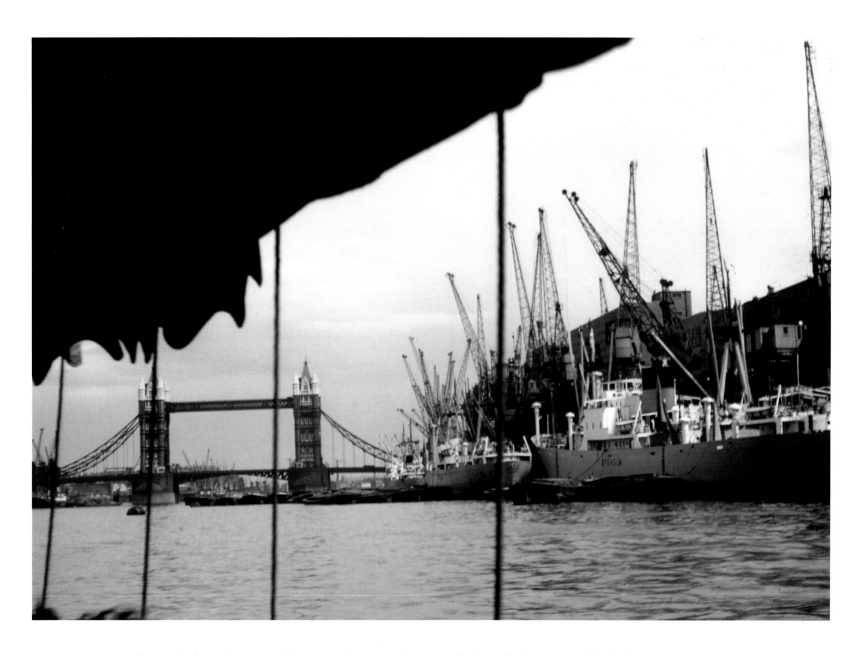

The Pool of London is seen here around 1957. Today it is a shadow of what it was and indeed Tower Bridge was designed specifically to allow tall ships to enter the Pool of London as it was, until the 1960s, a busy working dock in the centre of London. The docks seen here on the south bank have long been redeveloped and the scene is barely recognisable today.

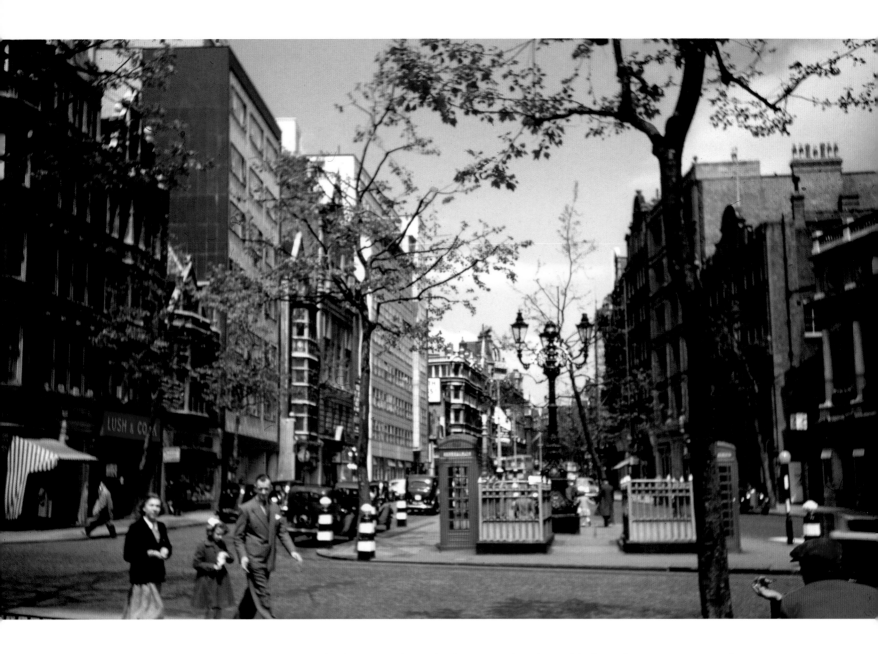

Charing Cross Road around 1952, looking towards Cambridge Circus, has changed little in the sixty years since this picture was taken. With the advent of mobile phones the red phone boxes have gone and the Underground toilets have closed. The bollards still retain their blackout markings and parking is not so easy here nowadays. Surprisingly for central London, the trees seem to have weathered the years well and there is more greenery here today than in 1952.

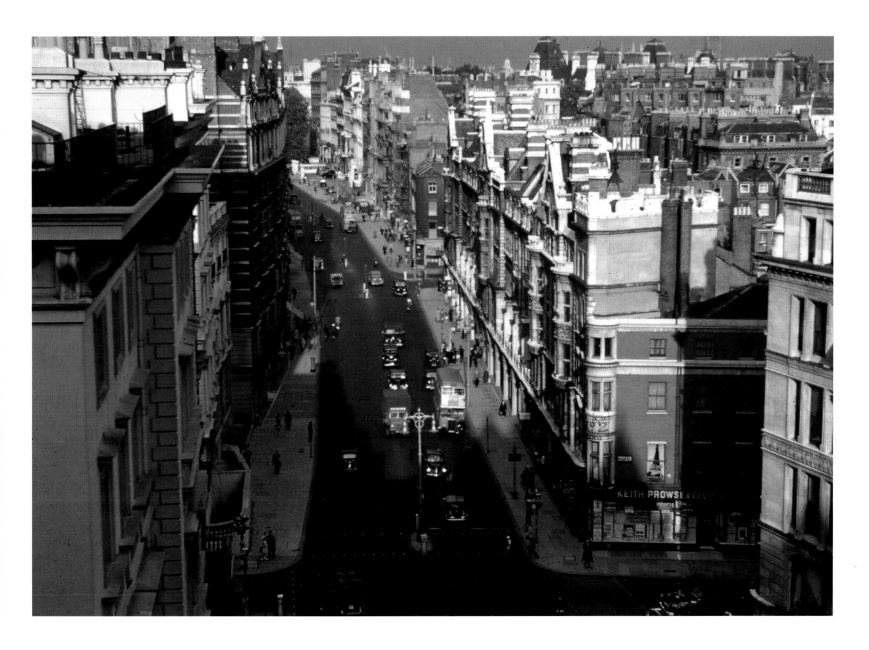

Looking along Knightsbridge towards Central London near William Street in 1948. Almost all the buildings in the foreground still stand, with the exception of the building in the extreme right-hand corner of the image. This is the A4 main road out of London to the west and is far busier today. Keith Prowse, after several buyouts and still trading today as a hospitality company, started out in 1780 selling theatre tickets. One hundred years later Keith Prowse appeared in the first UK telephone directory published in 1880.

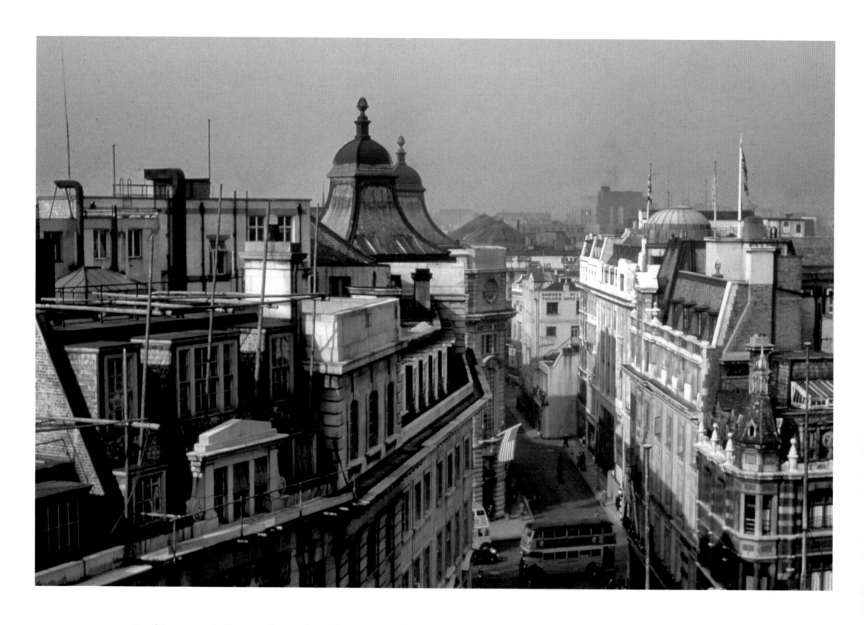

Looking towards Regent Street from the Regent Palace Hotel in 1948, several well-known businesses can be seen. Austin Reed, a clothes retailer founded in 1900, have only recently (2011) moved from the premises they are seen occupying here – between the two buses, on the corner of Regent Street and Vigo Street – but only to the opposite side of the street, having occupied the store for exactly a century. Further in the distance, Hawkes' Tailors can be seen at No. 1 Saville Row. Now known after a merger in 1974 as Gieves and Hawkes, they have been in the tailoring trade since 1771 and have dressed kings, presidents, prime ministers and dukes amongst their customers. A London Transport STL passes down Regent Street towards Piccadilly Circus.

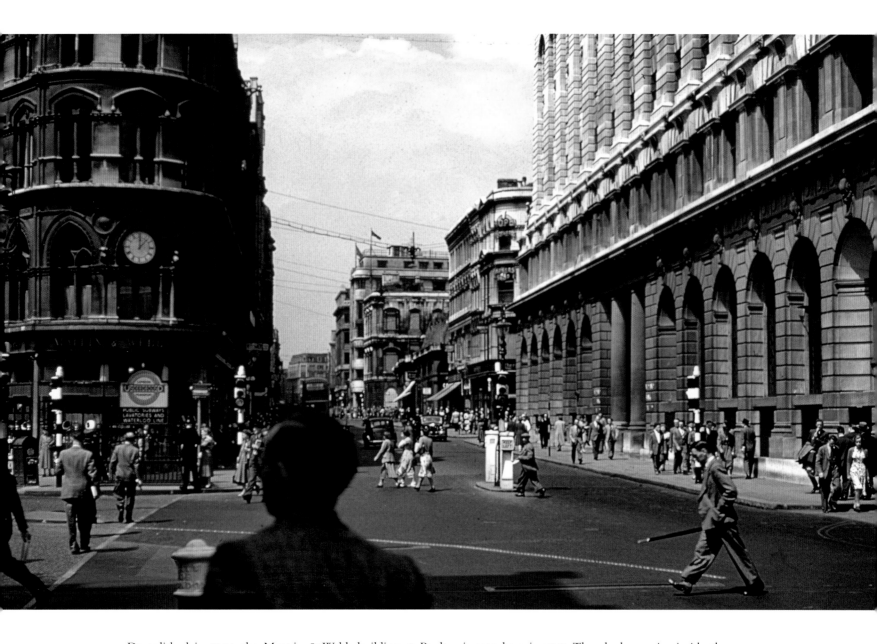

Demolished in 1994, the Mappin & Webb building at Poultry is seen here in 1951. The clock remains inside the replacement building as a memorial to the old. The building on the right-hand side of the photograph, the Edwin Lutyens-designed Midland Bank head office, was vacated by the bank in 2006 and sold. Virtually everything else in view, with the surprising exception of the boarded-up building in the middle distance, has gone.

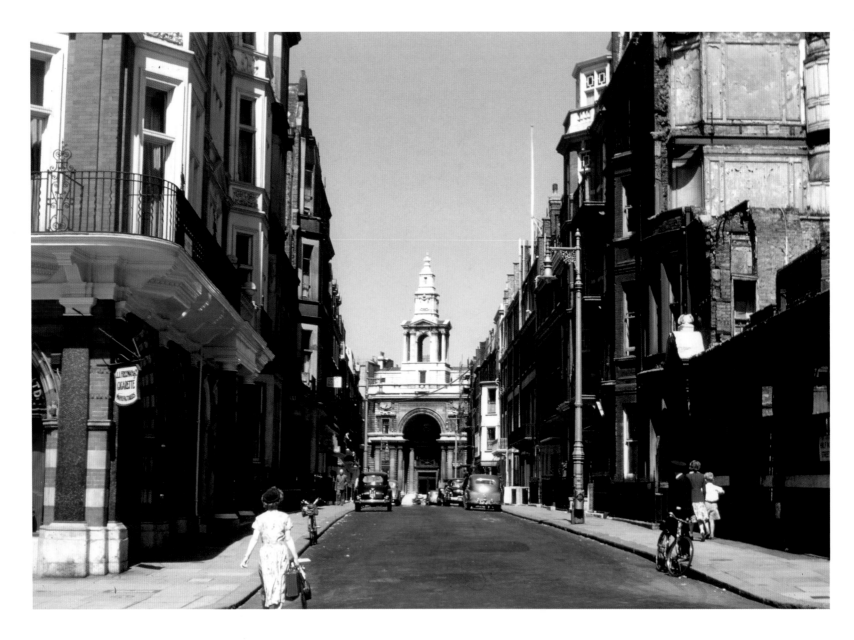

Half Moon Street in Piccadilly in 1952. It took its name from an inn that stood near here facing Piccadilly. On the right-hand side can be seen the result of a high-explosive bomb that fell during the Blitz. This gives some indication of how long war damage took to rectify, and this was by no means the only reminder of the war for Londoners. Even today, nearly seventy years later, unexploded bombs are still being unearthed during construction work. On the left is J. J. Freeman, cigarette manufacturers. Apart from the building on the right, little has changed here.

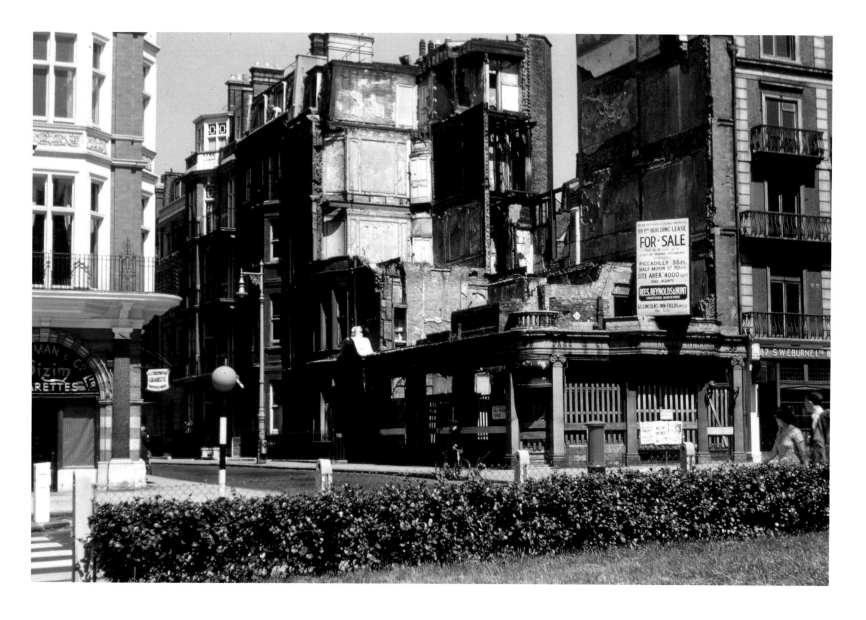

The other side of Half Moon Street is seen with the full extent of the war damage evident. The site, formerly housing Dare and Co. and Louis Coen, is on sale on a ninety-nine-year lease. It will now be over halfway through that by now! A new building was constructed on the site in the 1950s. Close examination of the building structure allows some details not usually seen: plasterwork, internal door detailing and construction of the building. Someone walking out of the doors that open out into mid-air may be in for a surprise! This also allows a glimpse of how buildings were stabilised after suffering bomb damage. Here the damaged building appears to have been cut back to good solid material to allow the retention of the buildings surrounding it to still be utilised.

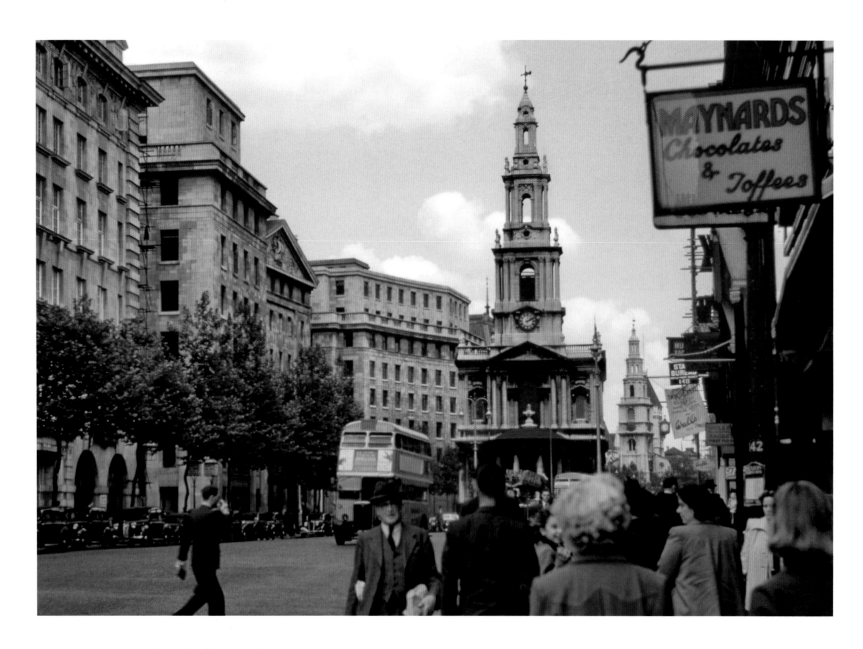

At the end of the Strand near Somerset House around 1956, Maynard's Chocolates and Toffees and Wall's Ice Cream are advertised on the shopfronts as we are walking towards the Aldwych Underground station. One of those rare images that takes you into the crowds walking along in London almost sixty years ago. The church in the distance is St Clement Danes and the nearer is St Mary le Strand. The bus, on service 11, is on a route introduced by the General Bus Company in 1906 and is one of the oldest continuously operated routes in London, although the actual route has changed slightly over the years.

The Clock Tower of the Houses of Parliament in 1955 was enveloped in scaffolding, part of an on-going restoration of the buildings that had started before the war. One of the most familiar images of London and often incorrectly referred to as Big Ben, the imaginatively named Clock Tower was an addition to the new Palace of Westminster. It had not been included in the original plan by Sir Charles Barry and was only added a year later in 1836 before building had commenced. It is the largest four-faced chiming clock in the world and Big Ben actually refers to the large bell that rings the hour chime. Big Ben is only a nickname and the bell is officially known as the Great Bell. Not terribly imaginative these Victorians! The Clock Tower was renamed the Elizabeth Tower in 2012 in recognition of the Diamond Jubilee of Queen Elizabeth II.

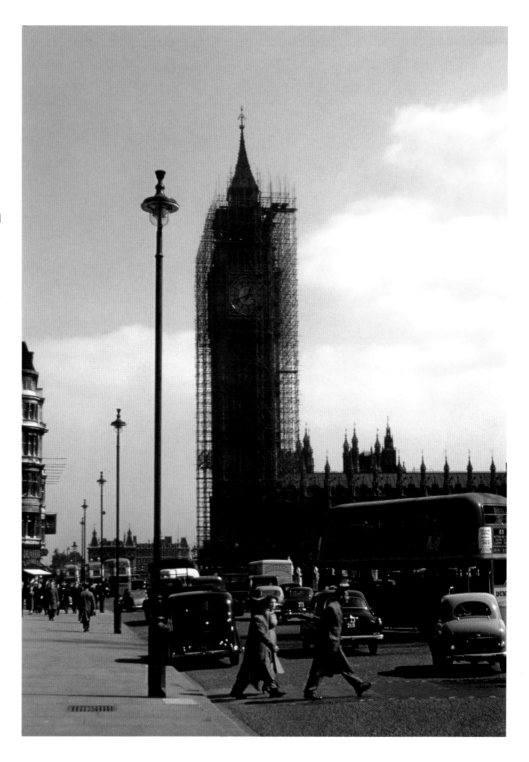

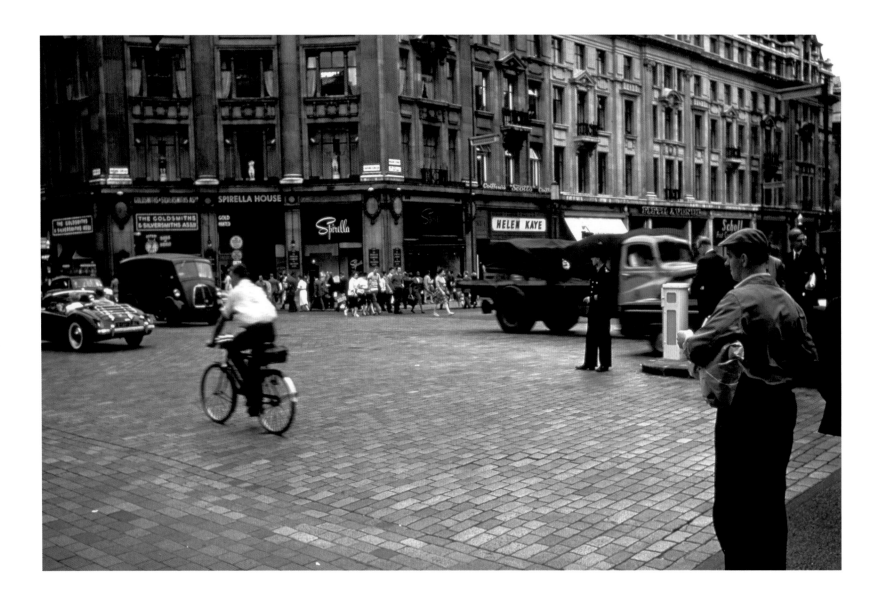

Spirella House, originally called Paris House, took its name from the Spirella Corset Company that was based here from the 1930s. By 1954, the corset company was still there and its wares can be seen in the first-floor windows. Spirella was taken over in 1985 and went out of business in 1989. The occupiers of the premises now, with no connection to Spirella, still sell ladies lingerie. Oxford Circus in 1954 was a busy crossroads with Regent Street and a policeman is on point duty directing the traffic. Fifth Avenue on Regent Street was an American clothes retailer – in 1950s Britain this was really avant-garde in the midst of post-war austerity. America seemed a different world back then, almost a week away by ship. The jet age would see air travel make the journey to America quicker, if still out of reach of the majority of the population. America was positively exotic in 1954.

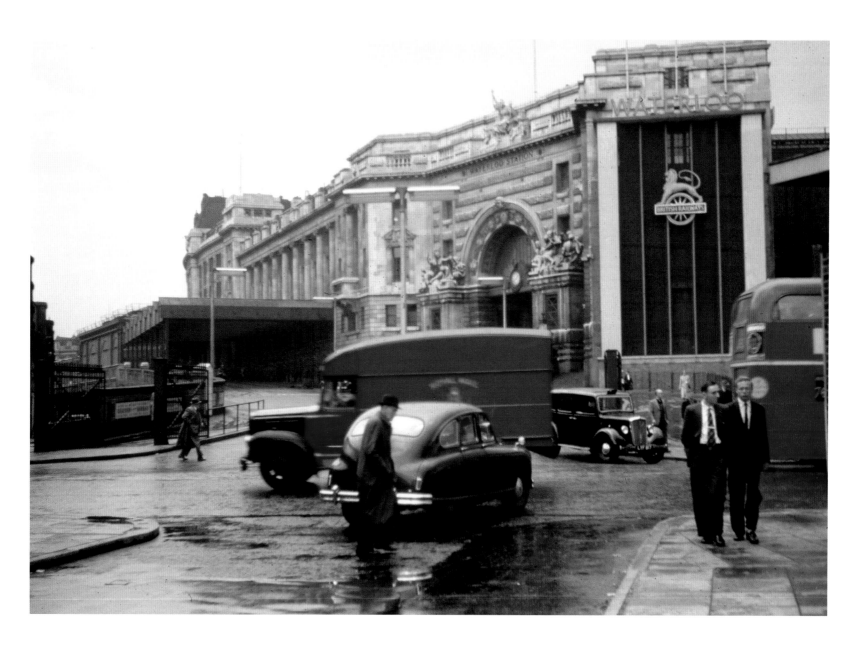

Waterloo station entrance after a heavy rain shower in 1956. The station has changed little but the road system has altered considerably round here. It is noticeable how few traffic control measures are in place. No yellow lines – they are still in the future. The canopy further along the road where the taxis wait has been cut back and the road where the bus and taxi are standing is now a multi-storey office block.

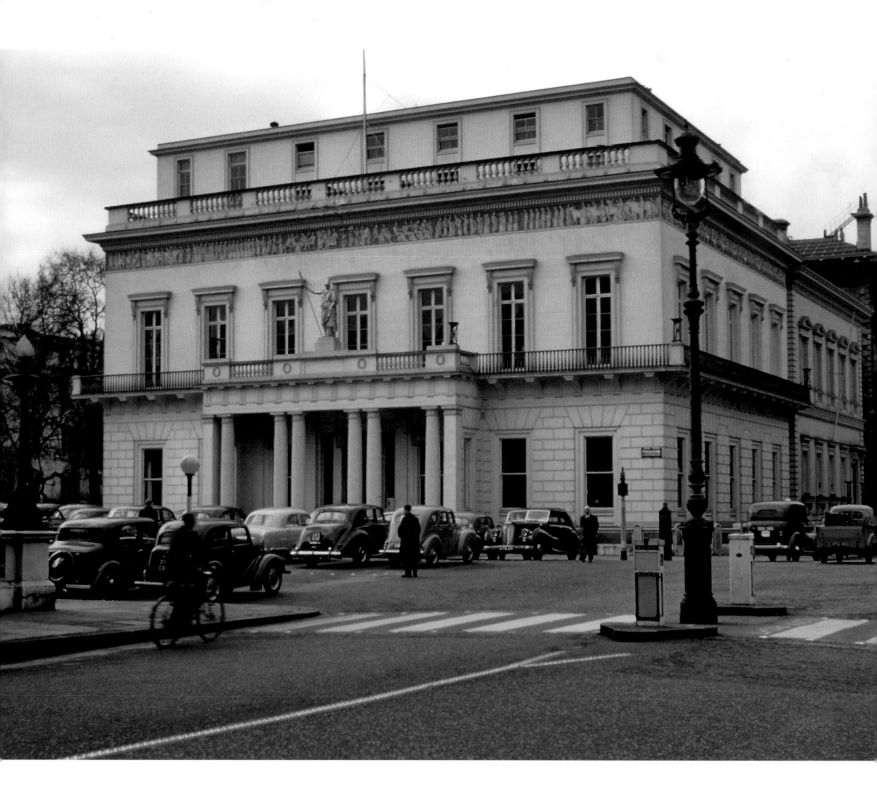

Left: The Athenaeum Club, on the corner of Pall Mall and Waterloo Place, is one of London's long-established gentlemen's clubs and is seen in 1948. Founded in 1924, it included some of the most famous names in British history, Winston Churchill and Michael Faraday being amongst its members. The cars parked outside would have a much more difficult time finding space here today.

Right: The Yeoman Warders of the Tower of London, colloquially known as Beefeaters, are the guards of the Tower of London. First formed by Henry VII in 1485, they are often referred to as the Yeoman of the Guard, which is actually a separate corps that split from the Yeoman Warders. Historically they are responsible for looking after prisoners in the Tower and safeguarding the British Crown jewels, but they mostly now act as tour guides. The uniform dates from the Tudor period but with differing initials dependant on the reigning monarch. Now it is E II R for Elizabeth II, but here in 1948 it is G VI R as King George VI is on the throne.

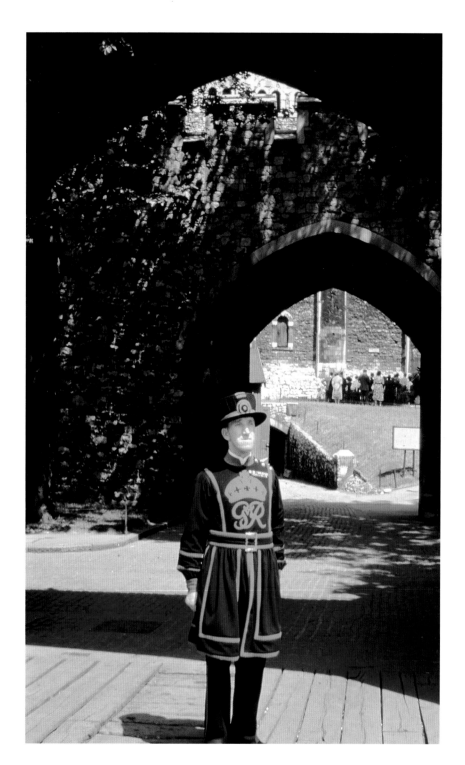

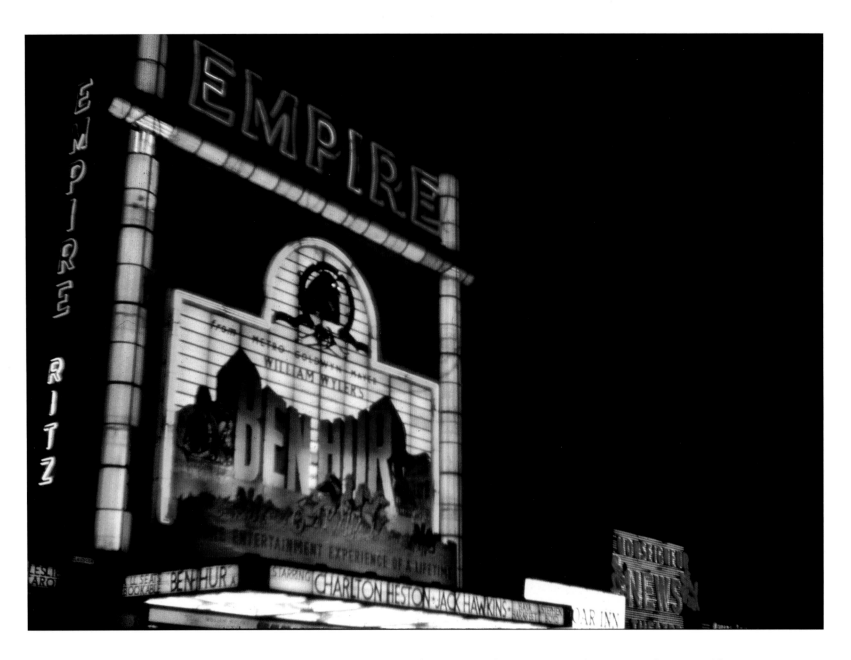

Ben Hur is showing at the Empire, Leicester Square on 3 February 1960. The cinema opened on 8 November 1928 with the silent film *Trelawney of the Wells*. It closed after a seventy-two-week run of *Ben Hur* in May 1961 and was completely rebuilt inside before reopening in 1962. *Ben Hur* was the last film shown (on new 70mm projectors installed in 1959) in the old 3,000-seat cinema. It has undergone several transformations since and is still open as a cinema but with eight screens now, the largest being Screen 1 with 1,330 seats – a shadow of its 1960 incarnation.

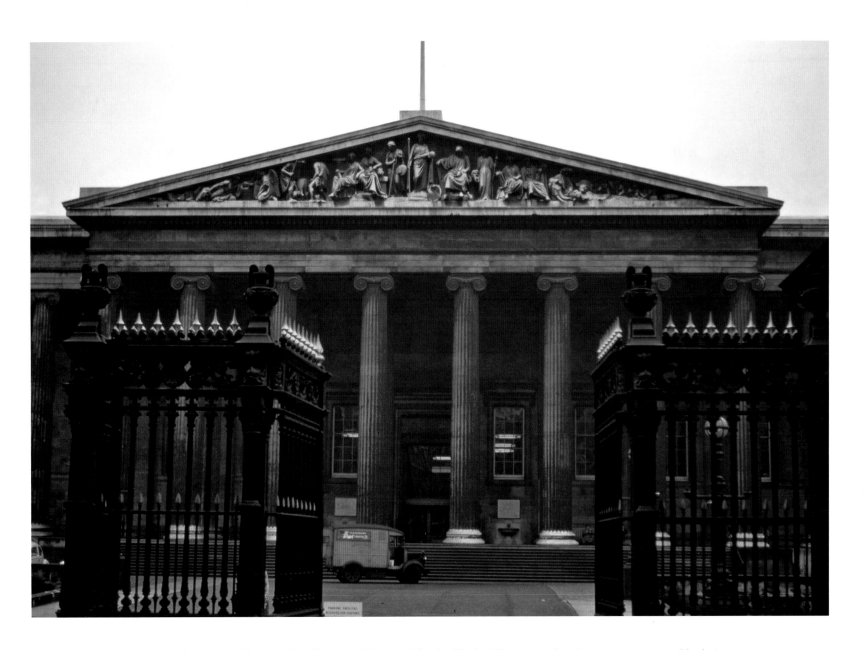

The British Museum blackened and begrimed in 1959. The familiar buildings were then just over a century old – being completed in 1852 – the museum itself having been founded in 1753. Even with collections from all over the world, august institutions still have to go about the mundane as well as the magnificent and here Royal Mail is doing its stuff with the day's mail being delivered. However, it is the notice at the bottom of the picture that proves of interest today. Parking facilities are reserved for visitors to the British Museum. The parking on the forecourt today is limited to disabled visitors only and must be pre-booked. London was far more car friendly in the past.

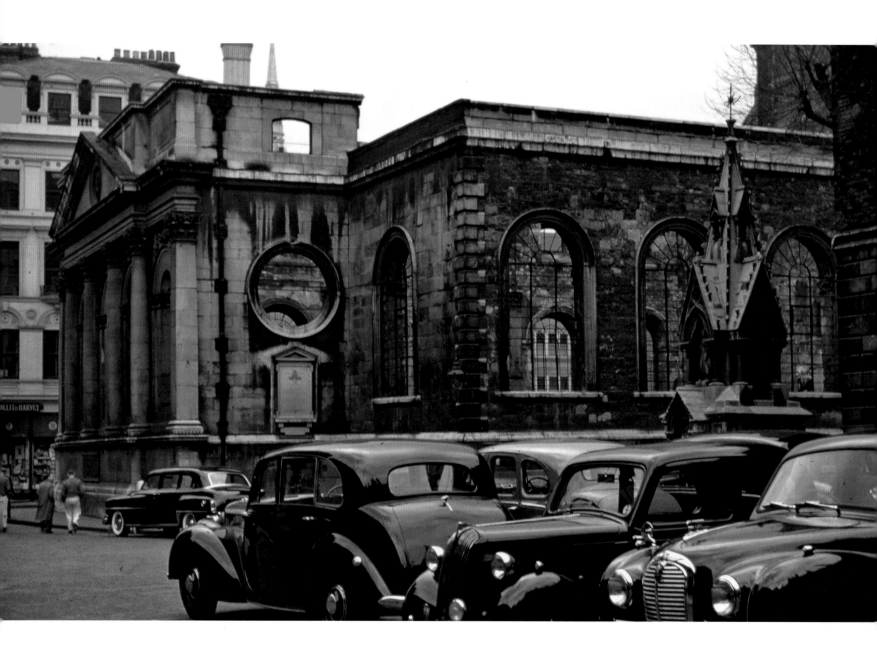

The ruins of St Lawrence Jewry in the early 1950s. Several London churches were not rebuilt after the damage inflicted by the Blitz but this was not one of them. Restored in 1957 to Sir Christopher Wren's original design, it is no longer a parish church, but is now a guild church and the official church of the City of London Corporation. Ironically, the building in the background, far younger than Wren's church, has gone now and has been replaced by a modern office block.

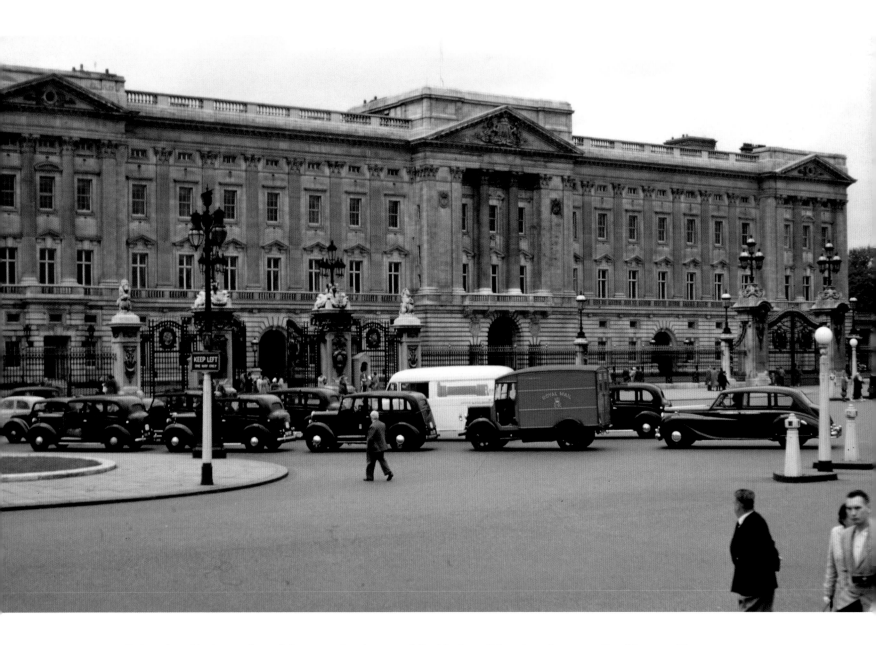

It is only with the passing of the years that images of Buckingham Palace have become of real interest. The stern edifice has been almost unchanged now for a century after its rebuilding in 1913 when the whole façade was re-clad in Portland stone to provide a suitable backdrop for the Victoria Monument.

A large proportion of the cars in this picture, from 1958, are taxis, and the Royal Mail van, a Morris Commercial LC3, dates from around 1948. Cars still travel down towards Buckingham Gate as in the photo but the road in front of the palace is now pedestrianised

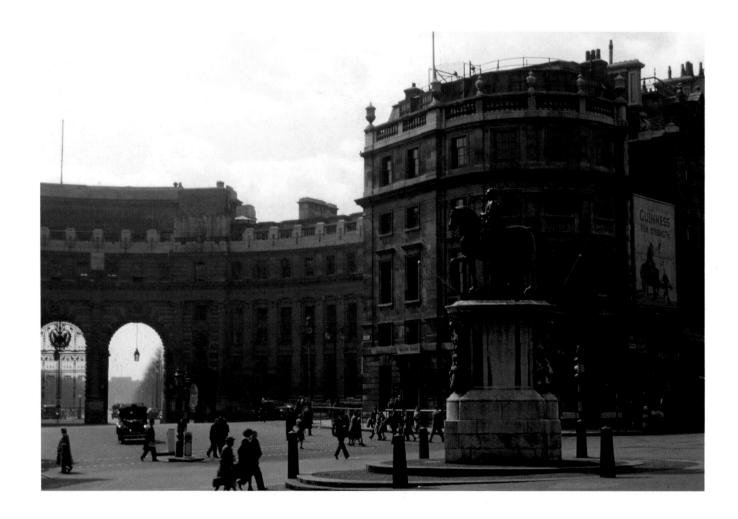

The statue of King Charles I looks down Whitehall. It was cast by the French sculptor Hubert Le Sueur in 1638, before the English Civil War. Following the war it was sold by Parliament to John Rivet, a metal smith, to be broken down. However, Rivet hid the statue until the Restoration, when it was placed on a pedestal at its current location. It was removed during the Second World War and, in 1949, when it was pictured here, it had only just been reinstated.

Admiralty Arch was built in 1912 and is the ceremonial entrance to The Mall leading to Buckingham Palace. Used as government offices until 2011 it has been sold on a 125 years lease and there are plans for it to be reopened as a luxury hotel.

The Guinness advert on the hoarding evokes an age when not *all* the claims made about a product were required to be demonstrably true. It exhorts 'Guinness for Strength' with a picture of a horse sitting on a cart pulled by a farmer. While an advertising icon, and one that got the artist John Gilroy a standing ovation when he walked into London's Garrick Club when the advert first appeared, it is not a true representation of the effects of a pint of Guinness – a fact that even the Guinness company admits to these days.

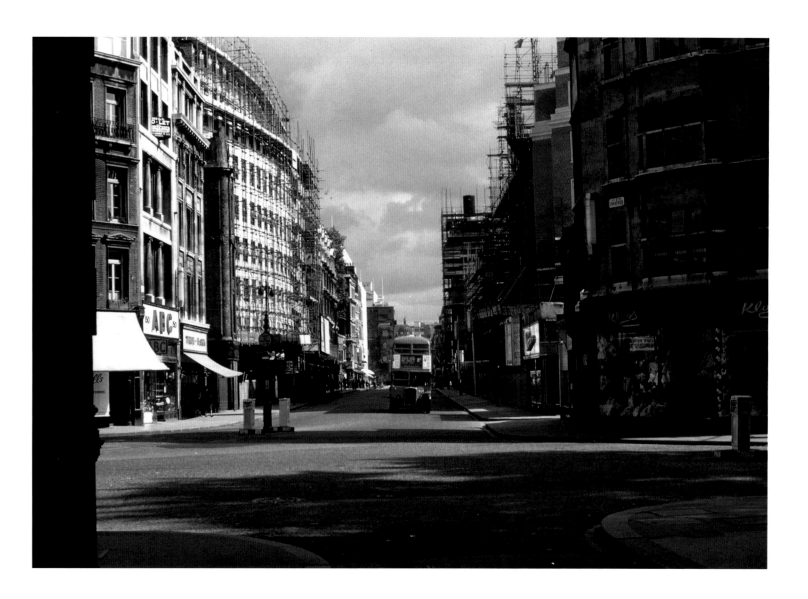

Cheapside, here in 1958, was a busy thoroughfare, although you may not think so from this image. It suffered severe damage in the Blitz but, by 1958, reconstruction was well under way. The brutal modernist block under construction is still extant today, but, apart from St Mary-le-Bow on the right covered by scaffolding, practically everything else in this view has gone – replaced by office blocks and shops. The character of the area has almost completely been eliminated. The ABC bakery (the Aerated Bread Company) had over 200 cafés in London – only Lyons had more – and, although the company was taken over by Allied Bakeries in 1955, was a well-known feature of the street scene in London until the 1980s. The shop next door to the ABC tea room is True-Form, a shoe shop in the Sears group which would, in 1962, acquire the Saxone shoe shop almost directly opposite.

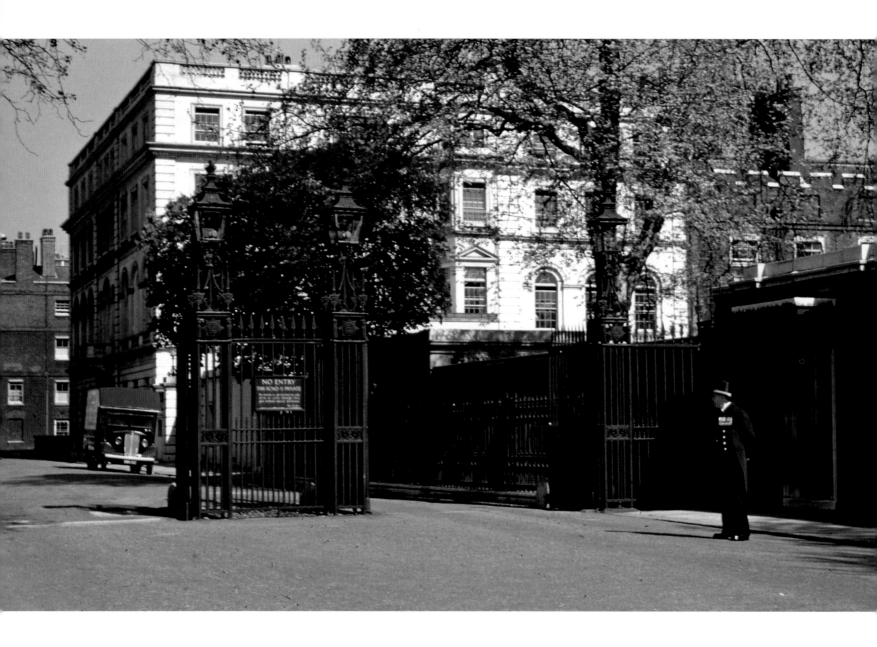

Looking up Stable Yard Road from The Mall is Clarence House, the home, when this image was taken, of the Queen Mother and Princess Margaret. The road is very definitely private, as the gates and the notice indicate. There is a delivery being made and the liveried gatekeeper standing outside Gate Lodges looks on. Security is low-key. The scene has changed little today and the house is now home to Prince Charles and Camilla, Duchess of Cornwall.

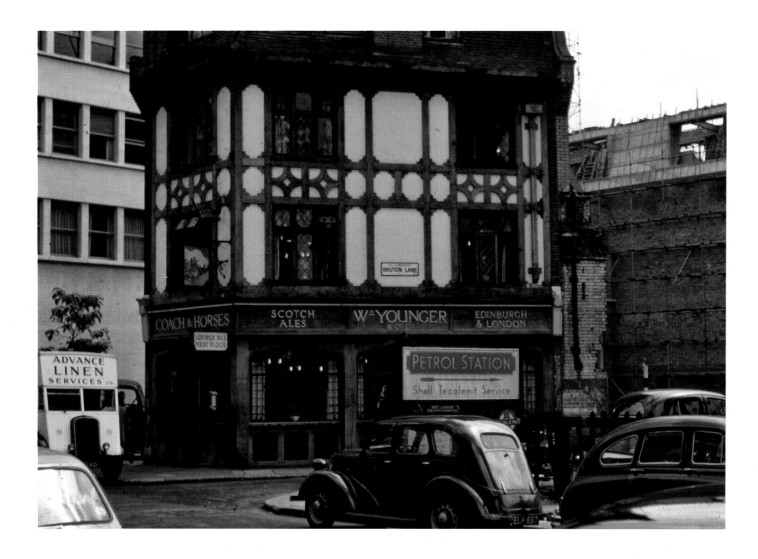

The Coach & Horses in Bruton Street, Mayfair, looking for all the world to be a Tudor-period building. However, all is not what it seems. After damage to the building next door the original Coach & Horses had to be pulled down. The Coach & Horses was rebuilt for William Younger & Co. in 1933.

Shell Tecalemit Service was a service for greasing cars. Established in 1922, the company still provides garage services today. The British Electric Traction Company was established in 1895 to run tram services and eventually grew to have extensive interests outwith their initial brief. By merger and acquisition they had holdings in bus companies, television, publishing and construction amongst others. In 1935 they bought an interest in Advance Linen Services Ltd to tackle the hotel and restaurant table linen market. This became a subsidiary of BET in 1955. Eventually, after divesting themselves of all their other interests and concentrating on the cleaning business, British Electric Traction itself was subject to a hostile takeover bid by Rentokil in 1996.

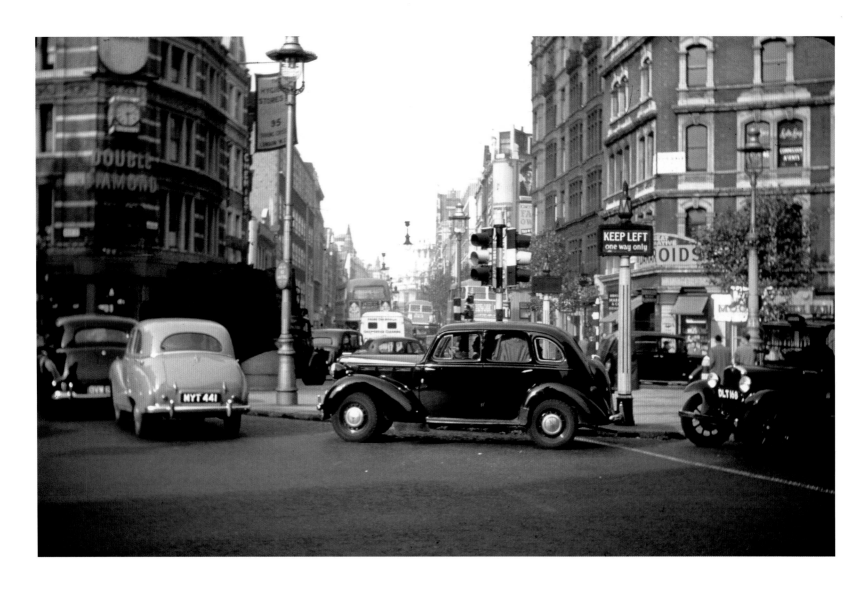

Cambridge Circus on the intersection of Charing Cross Road and Shaftesbury Avenue was still a roundabout in 1952. A 1930s Austin taxi just creeps into shot on the right-hand side and a lorry is heading towards Charing Cross Road with a large load of sacks of coal. Coal smoke contributed to what was known as a 'London Particular', the notorious pea-soup smogs that led to the passing of the 1956 Clean Air Act. Double Diamond was one of the first nationally available beers and was one of the most popular bottled beers of the 1950s.

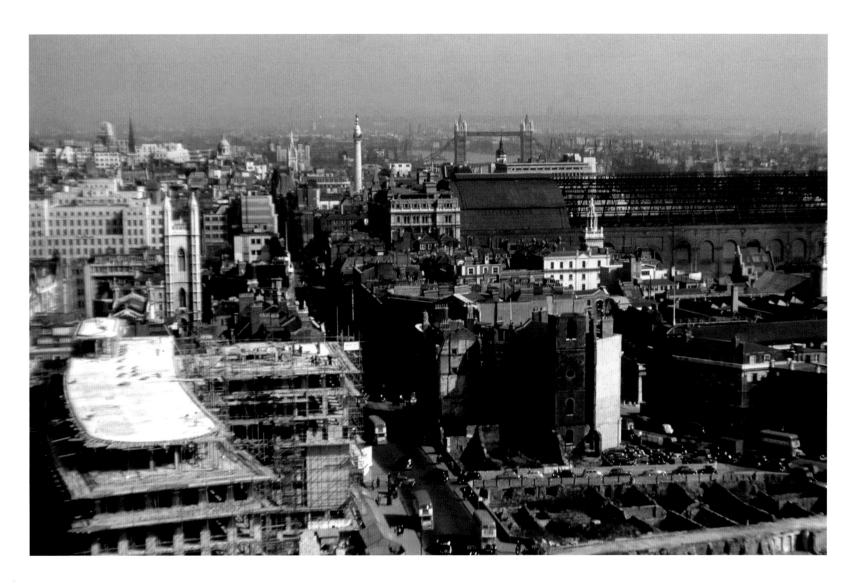

Looking east along Cannon Street from the dome of St Paul's Cathedral in 1953. Much new building work can be seen, as this area was devastated in 1941 during the Blitz. The arched roof of Cannon Street station can be seen, the glass still not replaced after the war for the very good reason that the building that it was stored in was itself destroyed by the bombing.

The Monument, in the middle distance, and Tower Bridge appear to be the tallest buildings visible, but now the view has changed, with the immense roof of Cannon Street station having been removed in the 1960s and an office building constructed above.

THE CAPITAL IN COLOUR 1910–60

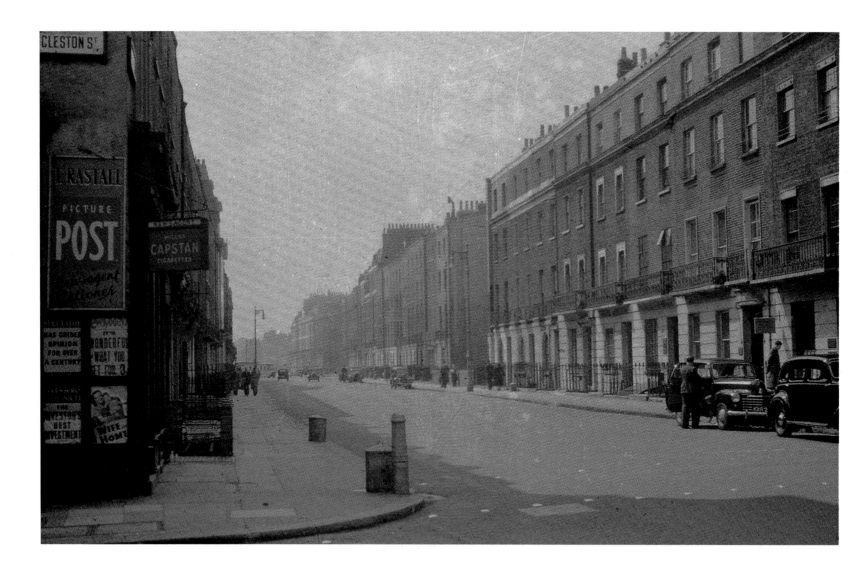

Another almost bucolic (well for London anyway) image of Pimlico in 1950. Ebury Street is almost deserted on what looks to be a day with the heat hanging heavy in the air, the sun bleaching the colours out of the buildings and the only splash of colour coming from the magazine adverts on the side of Rastall's newsagent and stationer at No. 81; *Picture Post*, *Everybody's*, *The Spectator* and *Wife and Home*. The latter was possibly a magazine that would raise eyebrows for a stereotypical and over simplified view of family life, perhaps even in 1950. The magazine finished publication in 1955. *Picture Post* and *Everybody's* were general interest magazines, with *Picture Post* featuring some excellent photojournalism; both would cease publication in the late 1950s. *The Spectator*, founded in 1828, is still being published and it is one of the longest-running British magazines focusing on political matters with a right-wing outlook. This shop had been a newsagent for over seventy years by 1950; however, it has recently changed to a bridalwear shop.

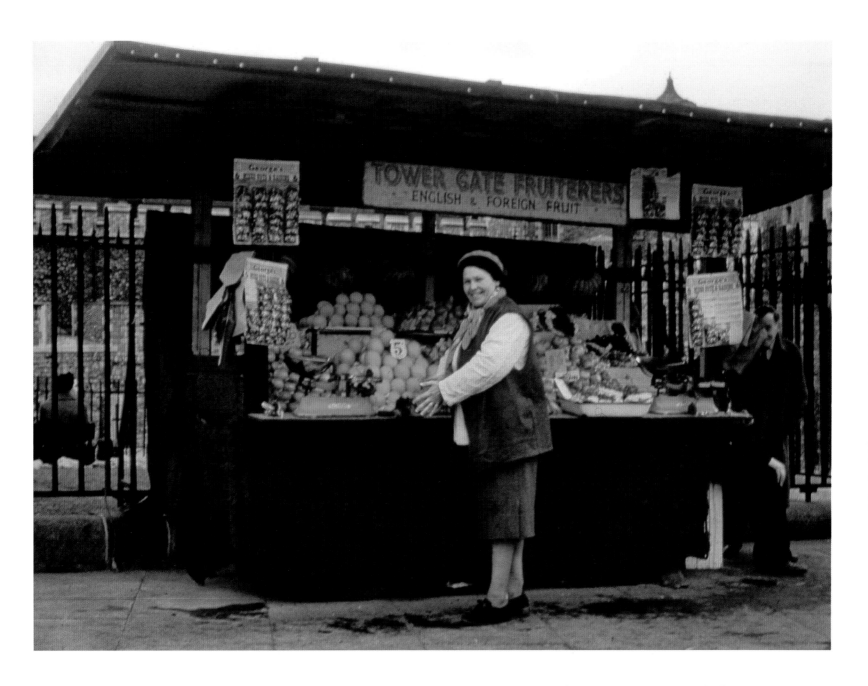

Tower Gate Fruiterers, retailing English and foreign fruit just outside the Tower of London in 1954, is typical of a London costermonger. They are still around today. The two brass scales and the brown paper bags hanging up place this shot firmly in period. Exotic fruits, such as promised by the stall's byline, will be expensive, with oranges at 5d each, but then London fruit stalls have never been cheap when they are situated at tourist traps.

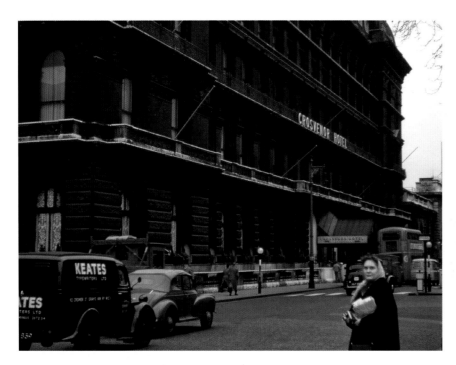

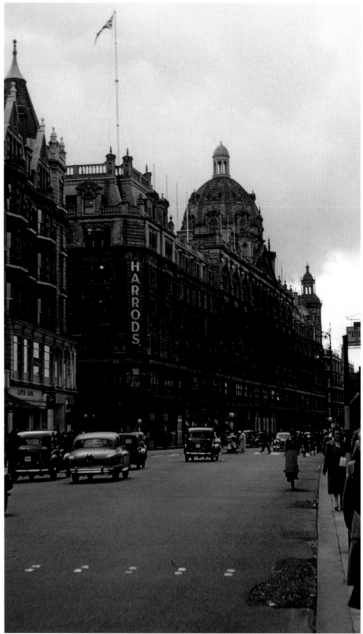

Above: The Grosvenor Hotel near Victoria station in 1956. Built in 1862, almost a century of grime and soot have blackened its walls. The years have not aged the hotel well and, although initially popular with the aristocracy, changing fashions and a lack of modernisation over the years had robbed the hotel of its popularity and it badly needed its recent refurbishment which has brought it back to its Victorian splendour whilst equipping it for the twenty-first-century traveller's expectations. Furthermore, with the stonework now cleaned, it is now no longer the black, unwelcoming edifice it was in 1956.

Right: Harrods on Brompton Road is one of the most popular shopping destinations in London. First established as a draper in 1824, the business moved to the present site (only in one room to begin with) in 1849, eventually expanding to fill the whole block. After a fire in 1883 the present building was constructed. Today there are 330 departments selling almost everything you could want. They no longer sell exotic pets such as lions, but it was perfectly usual to buy them here in 1956, a time when the traffic in Brompton Road seemed fairly quiet compared to the daily jams that bedevil this area of London today.

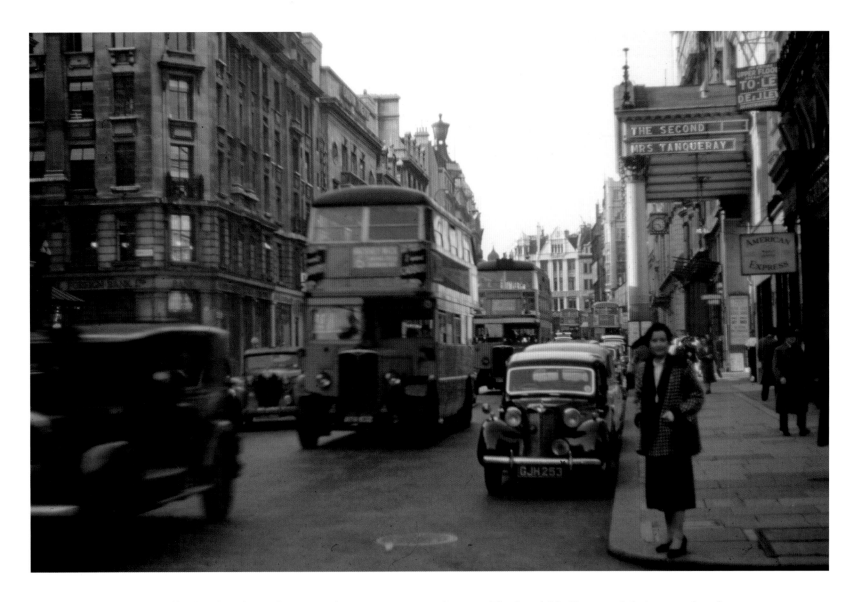

The traffic thunders down the Haymarket – one way even in 1950. *The Second Mrs Tanqueray* is being staged at the Theatre Royal Haymarket. This was by no means a first run of the play; it was written in 1893 and made a star of Mrs Patrick Campbell. It is one of the few plays to get a mention in a poem. It is referred to in Hilaire Belloc's cautionary verse from 1907 'Matilda' where, for telling lies, Matilda is refused permission to go to the play as a punishment. The humour rests with the premise that the play is not really suitable for children, as it deals with marriage outwith a social class, a woman with a 'known' past and an eventual suicide – Matilda possibly would not have enjoyed it anyway!

If you require it, the American Express office is on the right-hand side. Just try and park on this road today if you think it was busy back then!

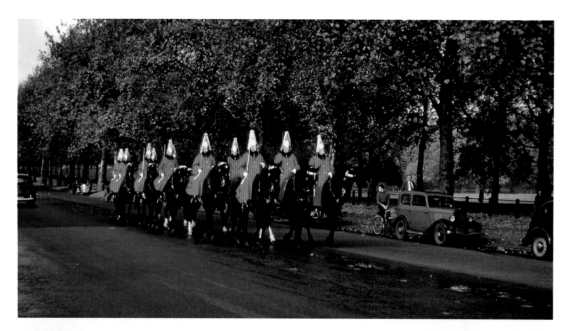

The Household Cavalry ride down Constitution Hill in 1952. It is a view almost unchanged today, over sixty years later, but parking is no longer as free and easy as it is here. Only the cars date this view and that cannot be said for many scenes in London.

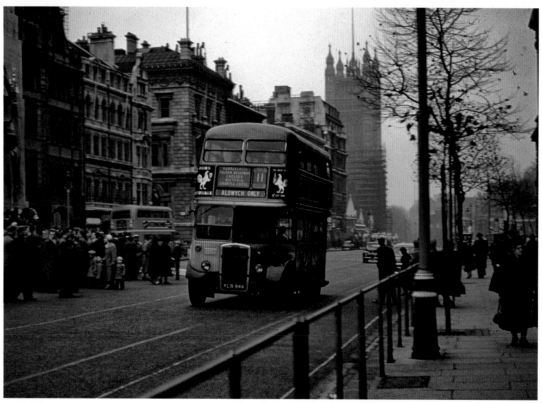

The trees bear witness here that it is late in the year and the cold wears its way into the bones of the people surrounding the Cenotaph as an AEC Regent RTW makes its way along Whitehall on route 11 towards Trafalgar Square. The scaffolding on the Victoria Tower of the Houses of Parliament dates this image to 1954.

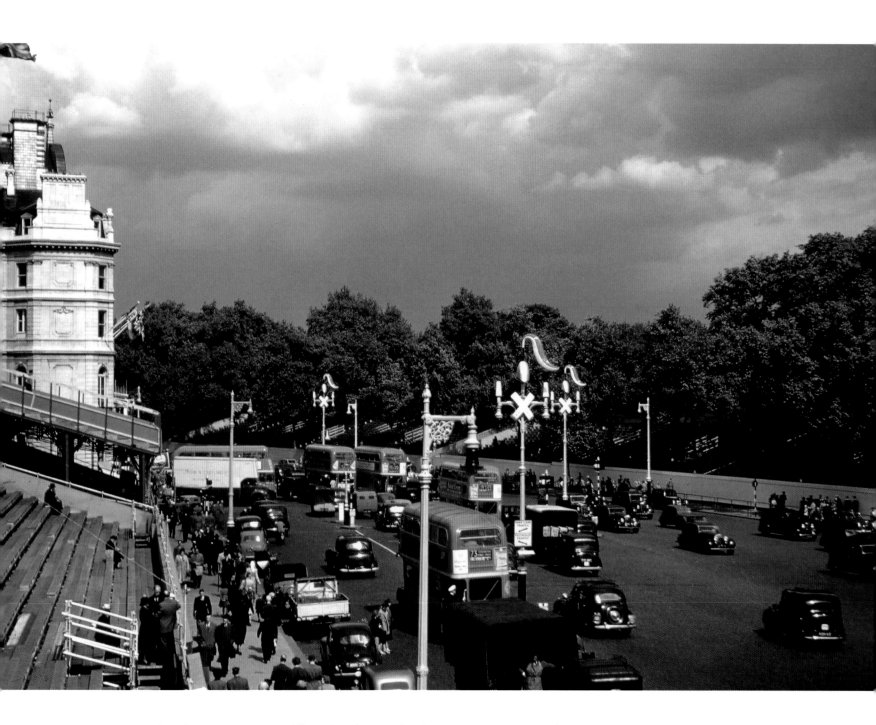

Grandstands set up near Piccadilly and Park Lane for the Coronation in 1953. The crowds would number almost 3 million and stands like this were set up all over the processional route.

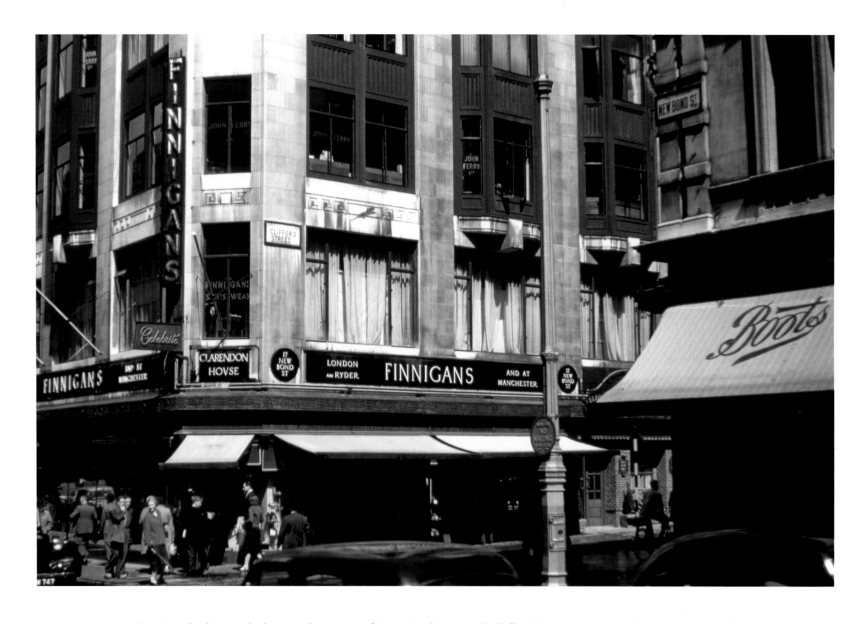

Finnigans leather goods shop on the corner of New Bond Street and Clifford Street, 1952. Clarendon House reminds us that the whole area was built on the Clarendon Estate, the large house of which was demolished around 1683 to create the area around Bond Street. Finnigans moved to these premises in 1900. The firm was originally founded in 1875 by Benjamin Finnigan at 16 Market Street, Manchester, and it later became a limited company in 1901 and had various addresses in Manchester, Salford, London (New Bond Street) and Liverpool. They were prestigious luggage makers and produced their goods from a factory at Deansgate in Manchester. Finnigans were well known for the fine quality of their goods. Louis Vuitton now occupies the premises, selling luxury leather goods. *Plus ça change*!

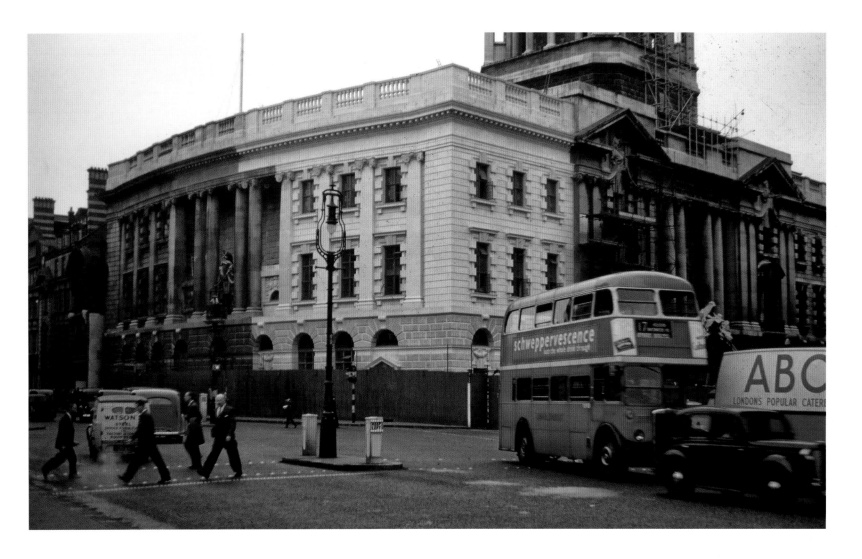

The past is a very different place from today. Values were different and certain buildings gained a perhaps undeserved reputation. During the period that this book covers, the death penalty in Britain was still in force and courts were a much more foreboding place as a result – wearing a black cap a judge would send convicts to the gallows. Dr Crippen, George Smith (the Brides in the Bath murderer) and Lord Haw-Haw (although not a murderer, treason was a capital offence) are amongst those that saw the judge place the black cap on his head to pronounce the sentence of death.

The Old Bailey was badly damaged during the Blitz and here the damage has been repaired; the almost blindingly white stone contrasts with the half century of pollution that has weathered the rest of the buildings.

A van leaves a trail of oil smoke as it wends its way. With the increased pollution awareness, sights like this are increasingly rare today, but in 1955 were not uncommon.

The ABC van is no doubt delivering bread and cakes to one of the numerous ABC tea rooms throughout the city.

THE CAPITAL IN COLOUR 1910–60

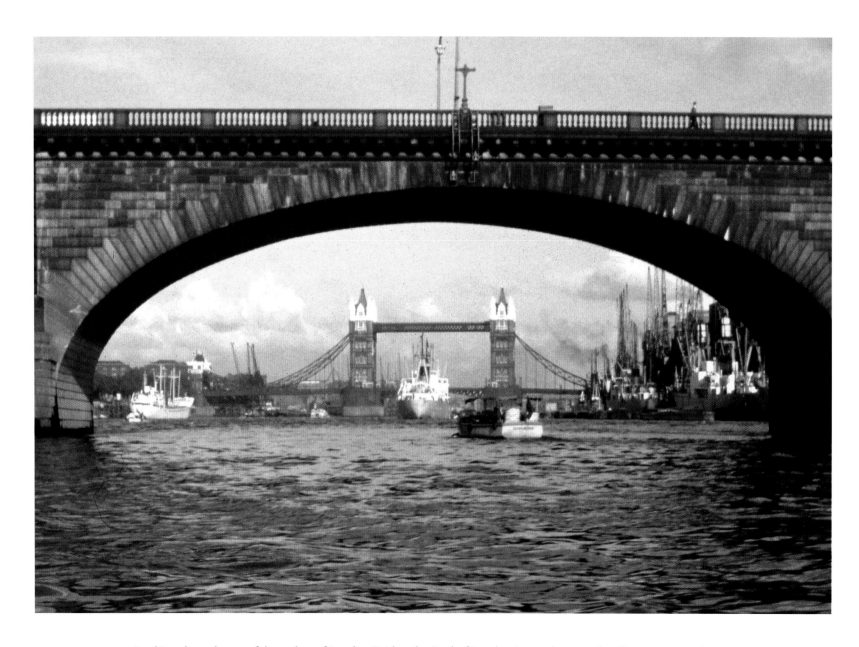

Looking through one of the arches of London Bridge, the Pool of London is seen here as a bustling port around 1957. London Bridge was opened in 1831 to replace an earlier structure, 'Old London Bridge', that had dated back over 600 years and had, until 1758, been covered with houses and shops. This 'new' bridge would itself be sold to America in 1967 and be replaced with the structure that is in use today.

Tower Bridge is seen downstream and the view shows how close to the city large vessels ventured before the port moved downstream in the 1960s.

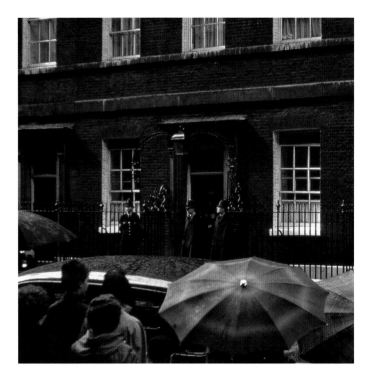

Tourists can no longer wander up Downing Street due to security restrictions; they can merely gaze up the street through the gates on Whitehall. However, until the 1980s it was definitely one of the stops on the tourist trail. Not initially appearing as imposing as some grand houses, it does in fact extend to over 100 rooms. Built, shoddily, as it transpired, in 1682–84, it eventually grew to absorb three houses – which explains why it is so large given the short frontage on Downing Street.

The shoddy construction was evident early on and the house has been restored several times. By 1960 the condition was so parlous that numbers of people in the upper floors was restricted and dry rot was widespread throughout the house. It was restored over a three-year period but, due to the Ministry of Works insisting on savings, corners were cut and only a few years later, in the late 1960s, dry rot was once again found and a further restoration was needed.

The bricks of the building are yellow, discovered during the restoration, but due to the dark character of the building being what tourists expect, they were painted black again to match the colour prior to the restoration.

Here a huddle of tourists waits in the pouring rain in 1958 to perhaps see the Prime Minister Harold Macmillan emerge.

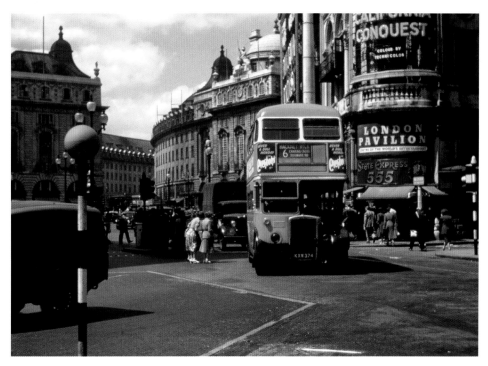

An unusual view of Piccadilly Circus in 1952 as a RTW bus makes its way round towards the Haymarket and on to Hampton Wick. New in 1950, its days in the UK were ended when it was sold to the Ceylon Transport Board in 1966. Regent Street curves away to the right in the background.

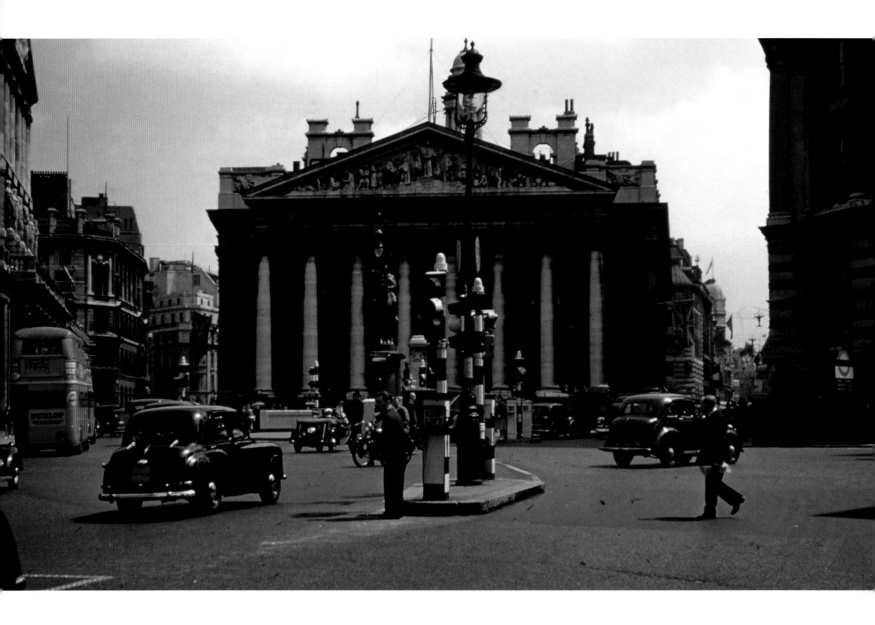

The Stock Exchange on Cornhill in 1951. The Stock Exchange no longer operates from here, having moved away in 1972. The large building on the left is the Bank of England and most of the buildings beyond that have gone, replaced by modern office blocks that tower above the older buildings, ruining the scale of the city. The junction is less of a free-for-all now than it was in 1951 and the buildings have been cleaned. London is a far cleaner city now than it was before the advent of the Clean Air Act. Before this Act thousands of coal fires had blackened the buildings over the years and had contributed to the epithet 'The Big Smoke'.

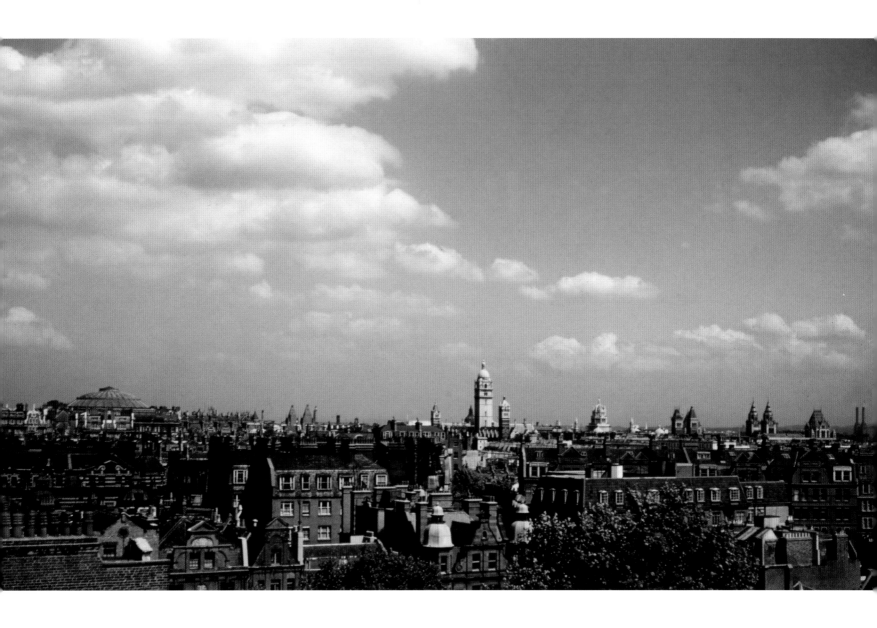

Derry and Toms was a department store in Kensington which was famous for its rooftop garden. Dating from the 1860s the company moved into the building on Kensington High Street in 1932. The store closed in 1971 but the gardens still remain today, a haven high above the street. The view from the roof is seen here in 1956. From the left the dome of the Albert Hall is prominent, with the Queens Tower at Imperial College near the centre, and at the right of the image the towers of the Victoria and Albert and Natural History Museums.

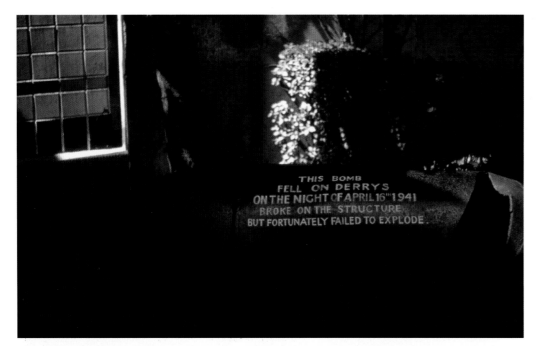

During the Second World War this bomb fell on Derry and Toms, luckily failing to explode and in 1956 it was on display in the roof garden. The building appears to have inflicted more damage on the bomb than the bomb on the building, which I suspect was not the Germans' original intention. Even some of the buildings seemed to have the Blitz spirit.

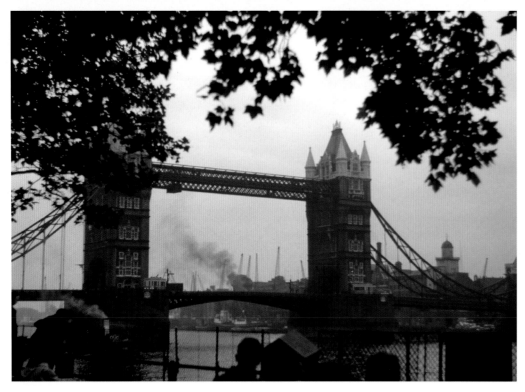

Tower Bridge in the mid-1950s, one of the standard tourist views that almost everyone photographed. The older river tugs were still largely steam powered, as was the bridge itself. A steamer beyond the bridge is brewing up nicely.

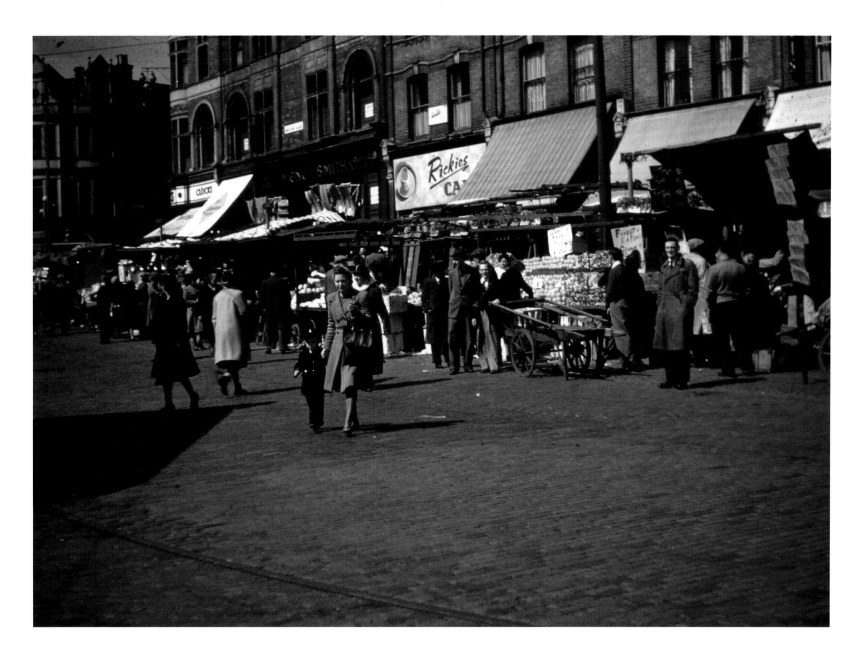

Woolwich Market, seen here in 1951, has changed a lot over the years. Mence Smith, household and domestic stores and Rickies Café are the only identifiable shops, as the then ubiquitous blinds have been pulled down to shield the goods on display from the effects of the sun and have rendered the rest anonymous. The costermonger has oranges and apples for sale and it all looks as if it would go on forever, but over sixty years of change has seen Woolwich transform almost out of recognition.

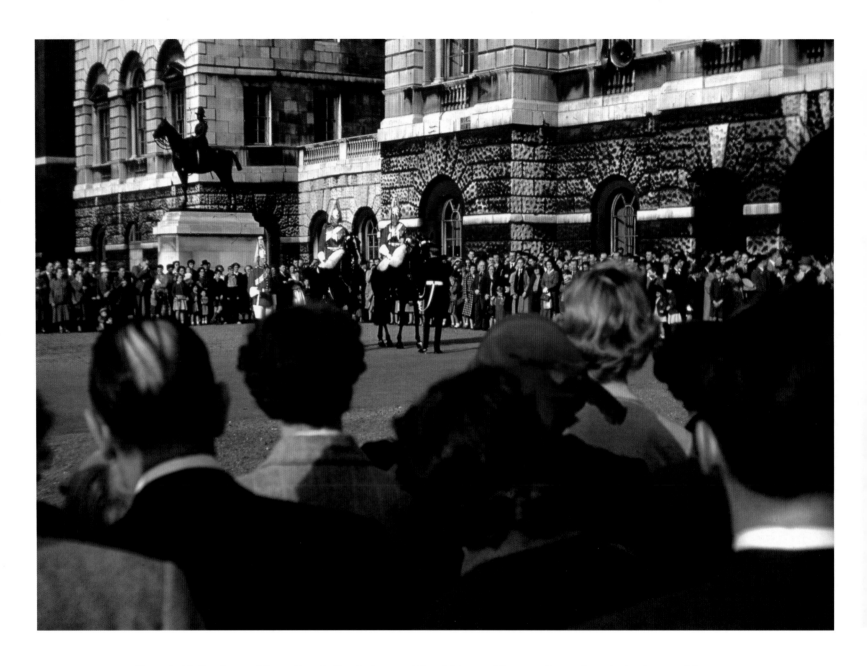

Household Cavalry on Horse Guards Parade in 1952. The fashions of the crowd are of particular interest. There are very few bright colours; instead there are greys, rusts, russets and browns with the occasional green and blue to enliven the palette. It would be later in the 1950s before colours really started to get adventurous. Although a few hats are in view here, there are now more men who are bareheaded, resulting in Brylcreem being in evidence!

VINTAGE LONDON

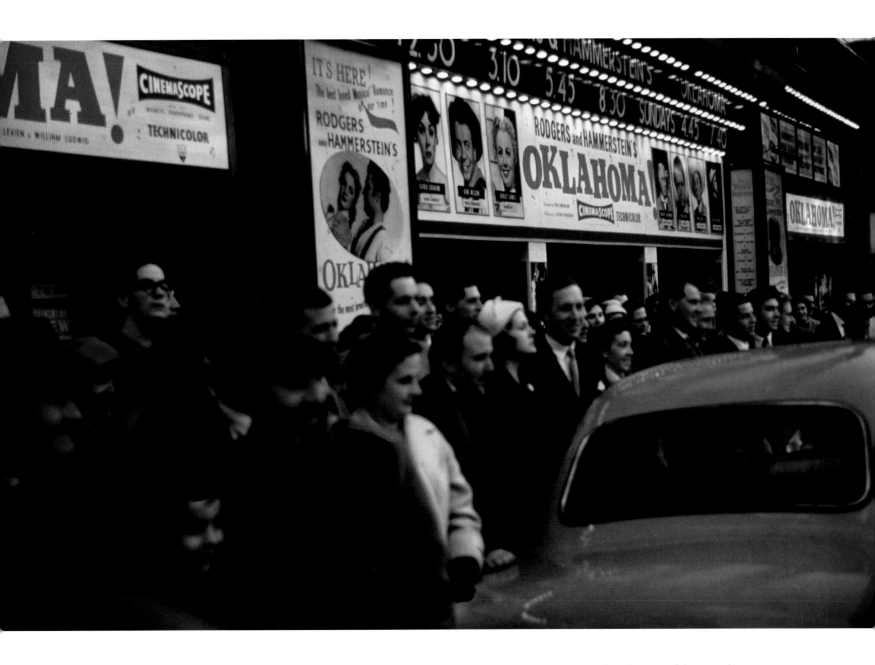

Oklahoma! – in Cinemascope. The pairing of Richard Rogers and Oscar Hammerstein produced some of the 1950s' most popular cinema musicals. The Odeon at Leicester Square is seen here in 1956 with an expectant crowd, possibly waiting for a VIP to arrive. The premiere was on 6 September but the crowd looks well wrapped up against a possibly chilly evening, so perhaps it is later in the year. Despite the overwhelming advertising for *Oklahoma!*, the *Gaumont British News* still manages a small billing on the front of the cinema.

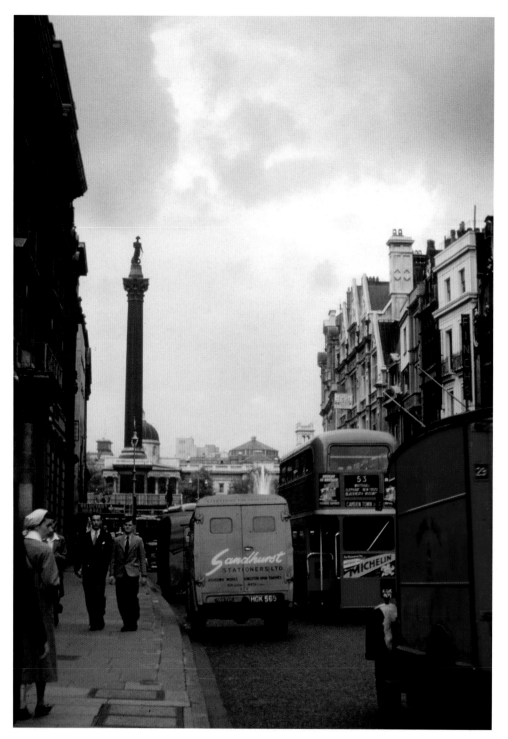

Left: Looking up Whitehall to Trafalgar Square around 1952 with the first of the Whitehall Farces, *Reluctant Heroes,* playing at the Whitehall Theatre. A Royal Mail van follows the No. 53 bus and an Austin van for Sanhurst Stationers looks to be parked up; there are no yellow lines yet.

Right: Soon after arriving in London, a foreign ambassador has an audience with the monarch. This is a formal ceremony in which a newly appointed foreign ambassador presents his or her Letters of Credence or Letters of High Commission to the monarch. The ambassador is collected from the embassy by a coach from the Royal Mews. Here in 1952 the new Israeli Ambassador is going to present himself to the Queen.

Right: Speakers' Corner in Hyde Park near Marble Arch in 1952, with the speaker on this occasion having an attentive and warmly dressed audience. This is an area where open-air public speaking, debate and discussion are permitted. It is also the site of the Tyburn gallows, which were used for public executions until 1783. As long as the police consider that speeches are not profane or illegal any subject may be debated, although heckling can be a constant problem for speakers. There is no immunity from prosecution for speakers should the police consider it necessary to do so if any complaints are made.

VINTAGE LONDON

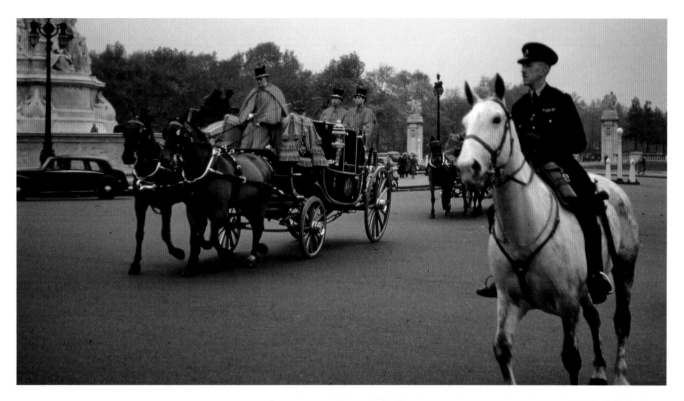

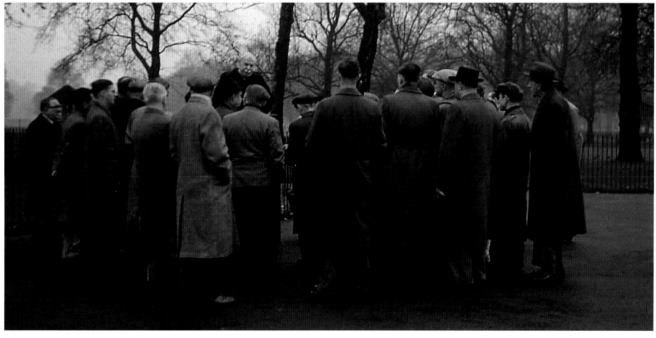

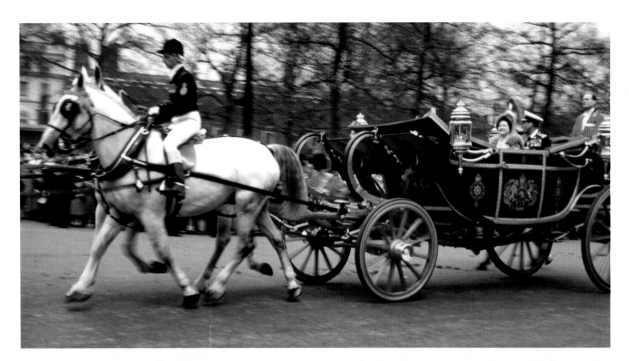

King George VI and Queen Elizabeth in a state landau travelling along The Mall towards Buckingham Palace in 1947. With the relatively slow speed of Kodachrome film the photographer has done well to capture the movement of the horses with very little blur as they trot along.

Leicester Square tube station on Charing Cross Road, here in 1952, is far busier nowadays. The station building was once home to the British Transport advertising division, but it is now an Angus Steakhouse. The whole bus queue is dressed conservatively, as people were sixty years ago, with perhaps the exception of the woman in the yellow and red striped coat at the head of the queue – there are always rebels!

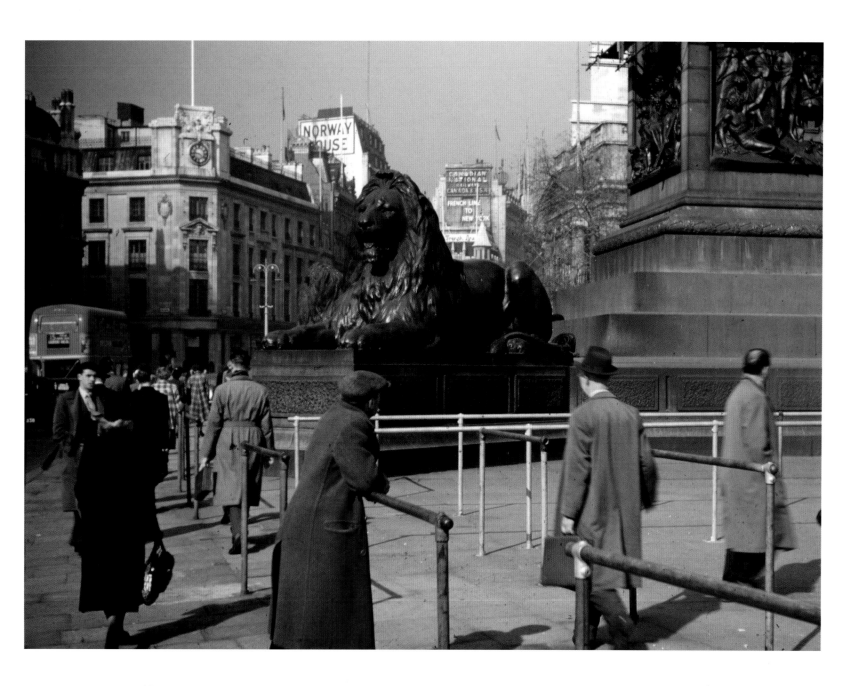

Trafalgar Square in the early 1950s with one of Landseer's lions on what looks to be a cold day judging by the way the pedestrians are wrapped up. You can almost feel the cold air nipping at your nostrils in the thin winter air. There is a Lyons Corner House not too far away on The Strand, so a warm tea or coffee possibly beckons! The No. 15 bus is heading for Ladbroke Grove having started in Poplar near the Blackwall Tunnel, a route of just over 11 miles.

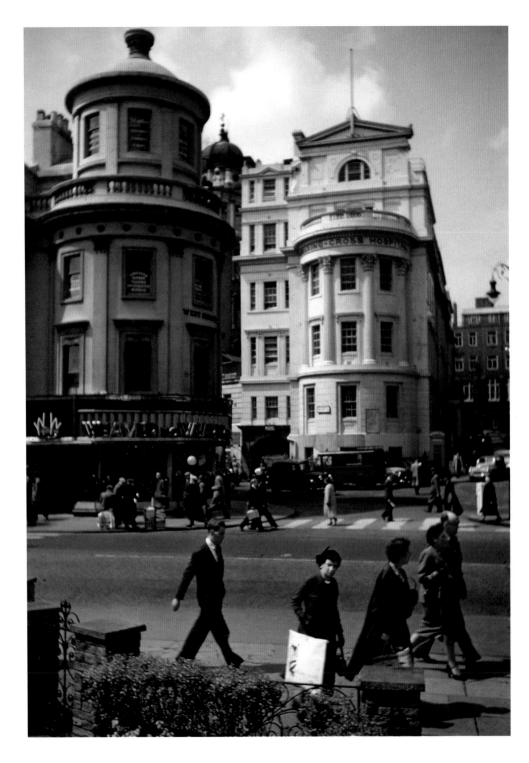

Charing Cross Hospital when it was at Charing Cross, *c.* 1955. The hospital would move in 1973 to its present premises in Fulham, a move having been under consideration since the end of the Second World War. The building is now Charing Cross Police Station. The Weaver to Wearer shop was a cut-price tailor under the Great Universal Stores group, which also had more upmarket tailors – catering for every pocket! Great Universal split up into two companies in 2006 and the premises is now a branch of Rymans, the stationers. There is now no trace at all of the greenery in the foreground.

VINTAGE LONDON

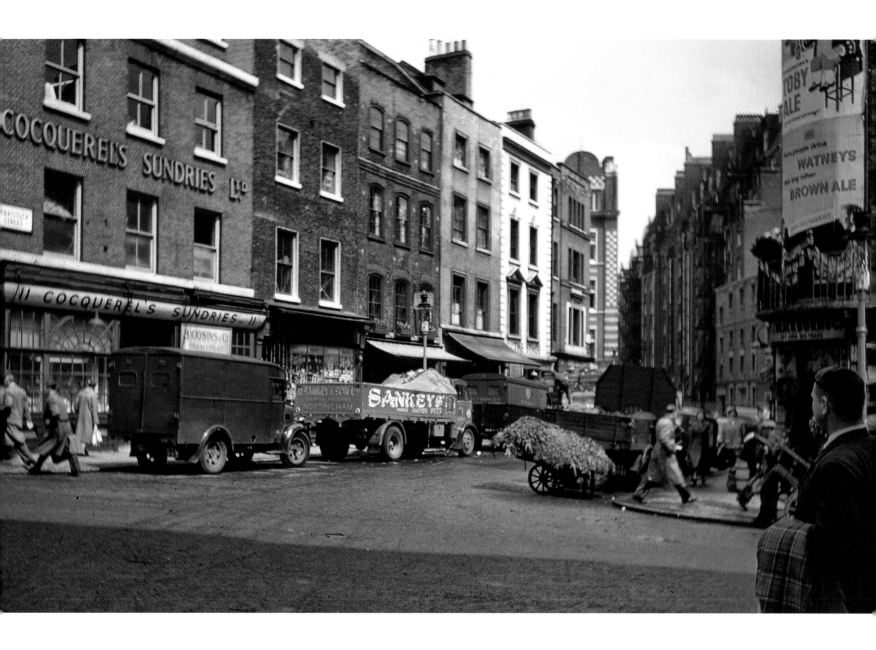

The buildings in Tavistock Street in Covent Garden have barely changed in the years since this photograph was taken in 1955; the businesses, however, have. *The Stage*, the magazine for the entertainment profession, has moved to South London and is still published and the quaintly named Cocquerel's Sundries still appears to be in business in South London as a florist. All the shops in this 1955 image are now catering establishments, as, after the moving of the nearby Covent Garden, the area has largely been taken over by tourists and theatregoers. Sankeys' still make plant pots and garden sundries today.

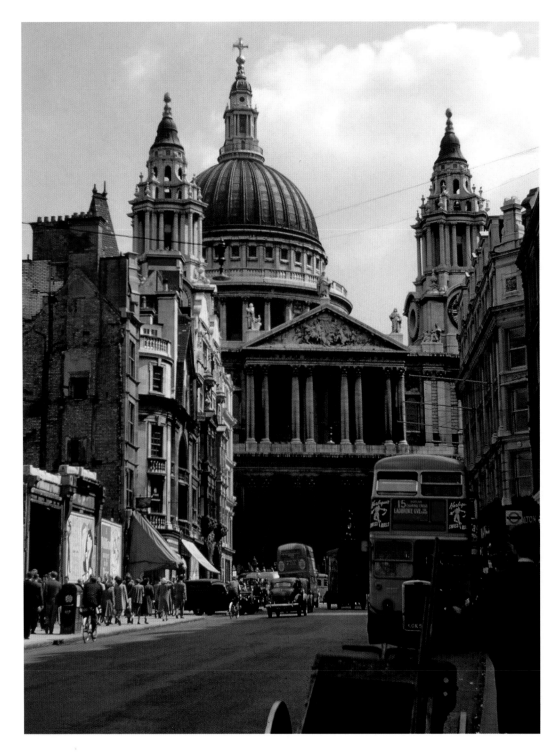

Blitz damage on Ludgate Hill in 1956. It took years of building before London finally recovered from the war, some areas not being rebuilt until the 1970s. Here the ubiquitous advertising hoardings hide the damage at street level while London goes on about its daily business. There are not many handcarts on the streets in central London these days.

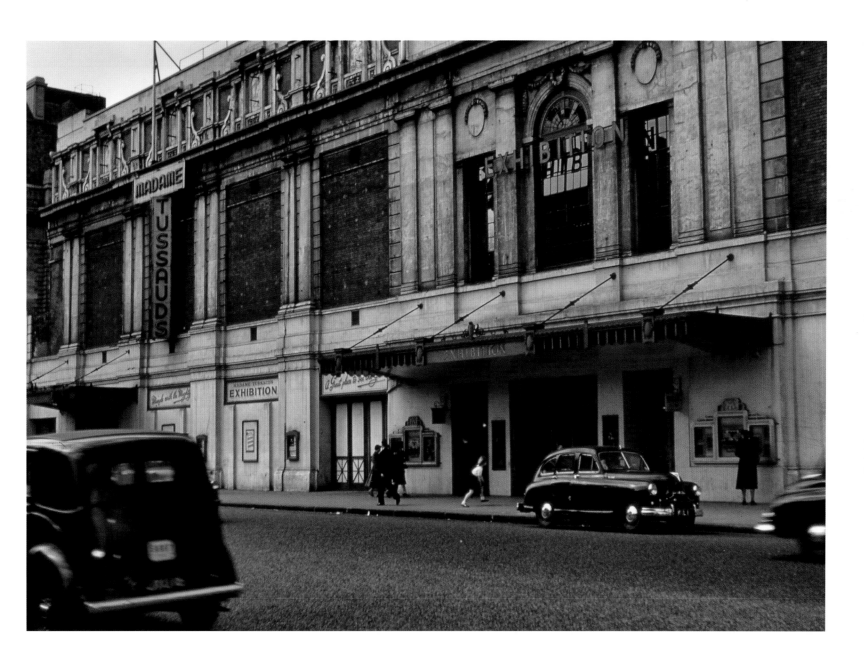

Madame Tussauds suffered in the war, as did the cinema, which was destroyed in the Blitz, and by 1954 the site on the corner of Allsop Place and Marylebone Road still had to be developed. It would be 1958 before the London Planetarium would open on the site – Tussauds having to get permission from the Board of Trade to import the projection equipment from West Germany. Tourists are enticed inside to see the waxworks with the byline 'Mingle with the Mighty'. Marylebone Road is not a place you would even think of parking these days.

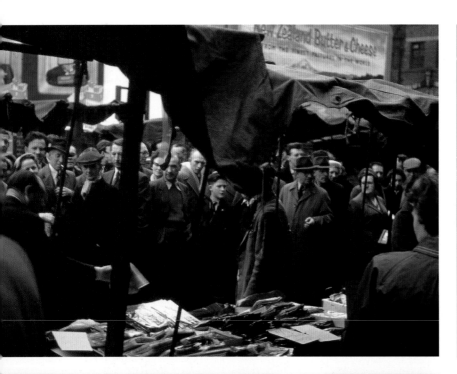

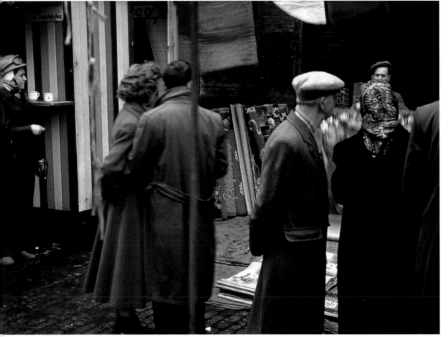

Petticoat Lane Market in the East End has been a market for over four centuries – possibly longer – although only legal since 1936. In 1951, when these images were taken, the East End was not the tourist attraction it is today: rough, blackened by soot and with large parts in ruins after the war, it was not top of the list for a day out when there was so much else to see in the city. However, if you wanted to see the real East End, you could queue up behind the motorcyclist for a cup of tea from the stall and mingle with the crowd; there wasn't a better place to go in London to hear the genuine patter of the locals.

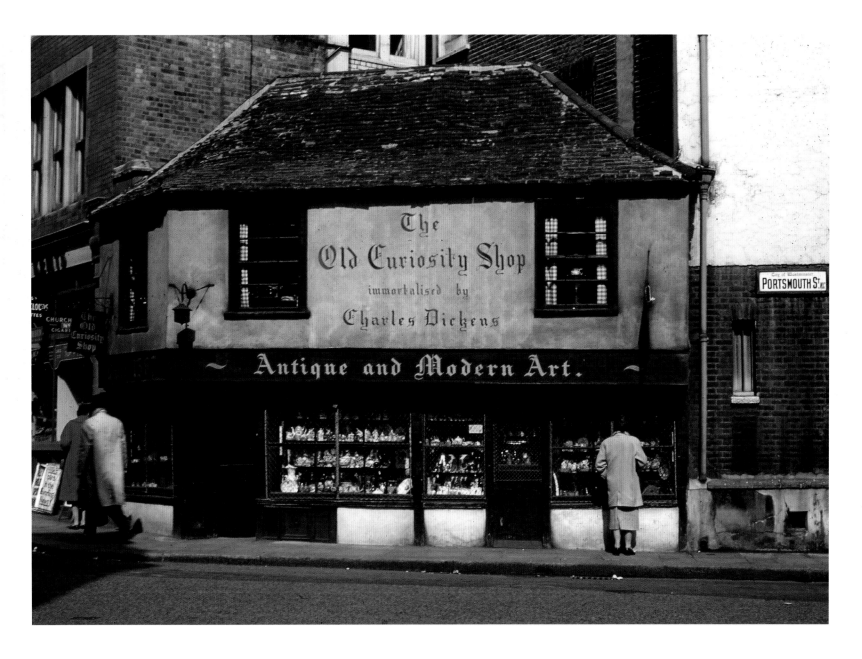

By the 1950s, The Old Curiosity Shop was an antique and modern art shop with windows full of antique bric-a-brac, providing a contrast to how it was in 1926.

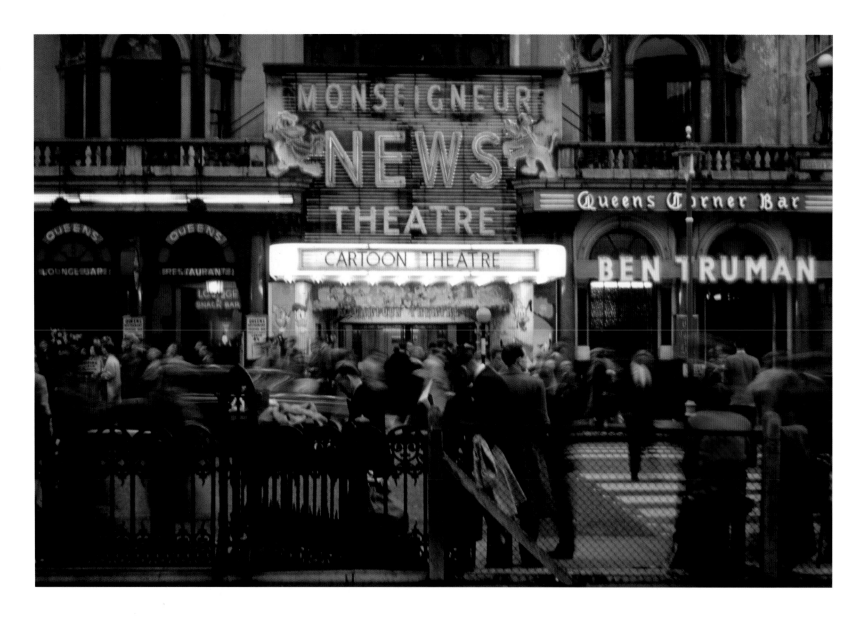

The Monseigneur News Theatre on Leicester Square, here in 1960, was originally the lobby area of the Queens Hotel, converted in 1936 into a cinema. However, by 1960, television, with its almost instant reporting ability, had largely superseded newsreels and the Jacey cinema group took over in June 1960 and started showing cartoons. London in the twilight with the neon lights glowing was a wonderful sight, but by 1970 this was not a place to take children, as by then it was showing adult films; London was going seedy. The cinema closed in 1978. Ben Truman, to the right of the theatre, was a brewery that was once one of the largest in the world, but changing tastes and cheap imports saw the brewery closing in 1989. The building is now Queens House, with a grill restaurant at street level.

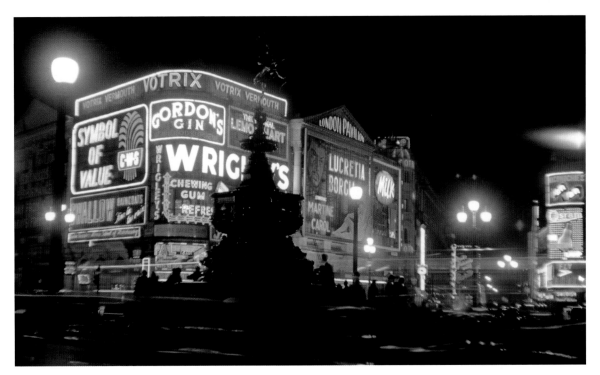

Piccadilly Circus at night in 1953, with Martine Carol starring in *Lucretia Borgia*, a film about ruthless power-seeking, murder and revenge (the Borgias are involved, so you may have some idea of how it all pans out). The Circus is still busy and people are mingling around the fountain. It is only when the Circus is seen at night that the full impact of neon advertising is apparent. This was a time when Britain was gripped by austerity, so the impact was far greater in 1953 than it would be today, as there are not as many neon signs and this building no longer has any advertising on it.

Looking along Tothill Street to Westminster Abbey early one morning in 1960. This is a typical row of shops: a cigar store, chemist, sandwich bar and fruit shop. Fyson's van is delivering bread, so there is perhaps a baker's as well, and it all looks as if it would go on forever. However, the site is now a Barclays Bank and the vast edifice of the abbey is all that remains here today, the buildings on the right having been demolished – not all vanished buildings were the result of the war.

THE CAPITAL IN COLOUR 1910–60

Left: Rothmans horse-drawn delivery brougham (a light, four-wheeled horse-drawn carriage) wheels round into Waterloo Place from Pall Mall in 1954. The photographer has panned round slightly, rendering the background slightly blurred. Deliveries were made in central London to clubs and embassies by brougham and footmen using this 1846-built coach that Rothmans had acquired in 1946. The immaculate finish is due to twenty-one coats of paint and four of varnish.

Below: Regent's Park Open Air Theatre, come rain or shine, has been a summer tradition in London since it first opened in 1932. Here in 1959, *Twelfth Night* is performed. In the cool of a late summer evening in the shade of the rustling trees, Shakespeare takes on a different atmosphere than in a conventional theatre, and is perhaps more akin to the type of performance that would have been staged in the Jacobean period by a troop of players around the country.

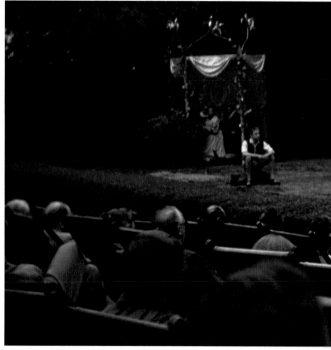

Right: A panorama of Oxford Street in 1953. At least twenty buses are in view, along with several private cars and a couple of vans. The shops on the north side of the road all have their sunshades down. The sight of a shopkeeper with his wooden pole, with a hook on the end, pulling the shades down in the morning to protect his wares from bleaching in the sun, is almost forgotten today.

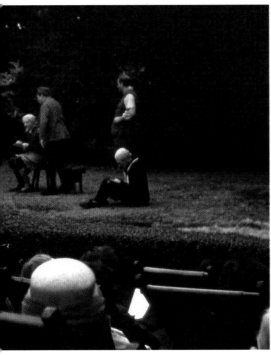

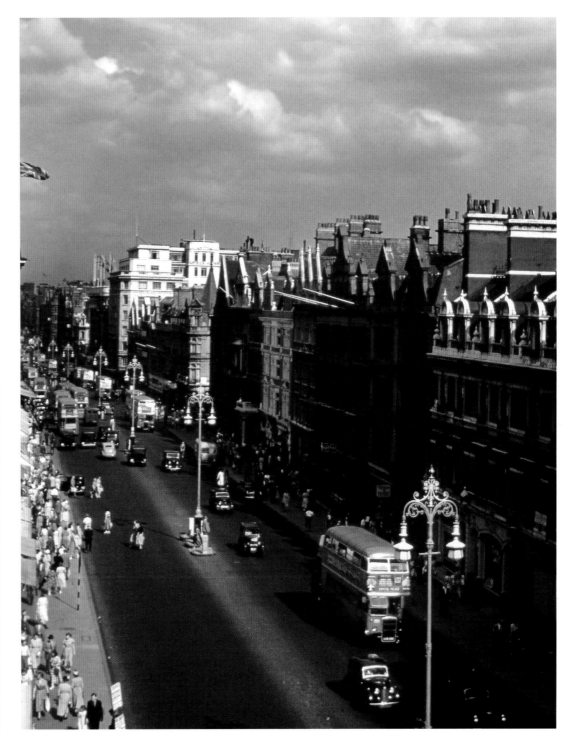

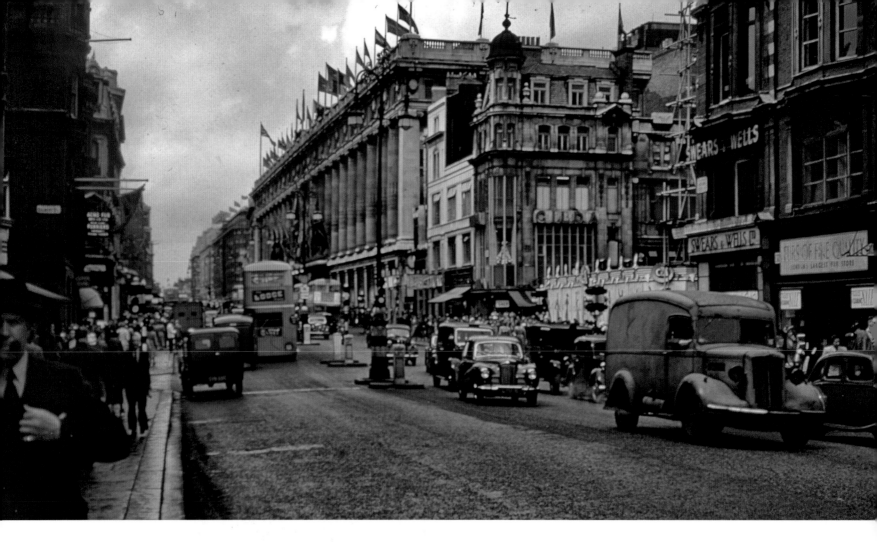

Oxford Street is one of the more photographed of London's streets, and Selfridges is one of the most photographed stores due to its imposing frontage. However, it is rare to have a distant view of the shop, but this allows more of the street to be seen. A van leaves a trail of oil smoke as it passes Swears & Wells – a furrier with branches all over London – which has a sale on. The shop was so well known that it merited a mention in Gilbert and Sullivan's operetta *Patience*, written in 1881:

> We're Swears & Wells young girls,
> We're Madame Louise young girls,
> We're prettily pattering, cheerily chattering,
> Every-day young girls.

If you were customers of Swears & Wells or Madame Louise – two of the finest ladies' furriers and milliners in town – then you had arrived!

The Swears & Wells building still stands, but is a Body Shop today. The building just past the gap site to the left of Swears & Wells still stands today, but the gap site has been redeveloped. Selfridges still stands sentinel over Oxford Street as it has done for the past century.

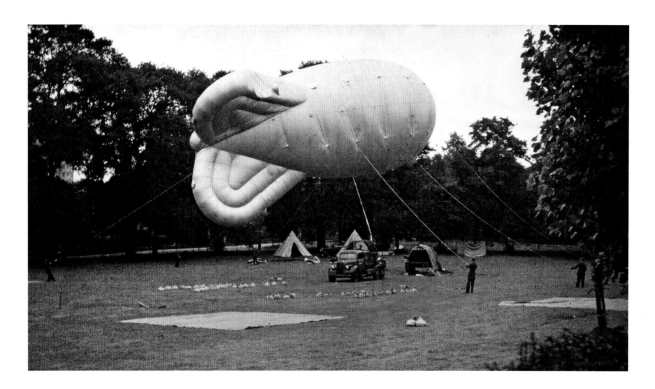

London was perceived, rightly as it turned out, to be a major target for an air attack in the Second World War. Barrage balloons were deployed in London and by mid–1940 there were over 400 of them around the city. Here, in 1939, one is seen being deployed in Norwood Park in South London. It is often thought that the ban on photography during the war was only an assumption that certain things must not be photographed, but as an article on 11 September in the *Daily Telegraph* stated:

> A wide range of things of which photographs must not be taken, or sketches or plans made, without a permit was mentioned in a War Office Order issued last night. The Order comes into force forthwith.
>
> They include any fortification, battery, searchlight, listening-post or other work of defence, any aerodrome or seaplane station, any assembly of the King's forces, factories or stores for munitions, wireless, telegraph, telephone, signal or cable stations, docks, harbours, shipbuildings, works or loading piers.
>
> The ban also applies to war vessels complete or under construction, to vessels or vehicles engaged in transport of personnel or supplies, aircraft or the wreckage of aircraft.
>
> Buildings or vessels damaged as the result of enemy action are also covered, as well as hospitals, casualty stations, electricity, gas or water works, roads of railways exclusively connected with works of defence, and accommodation for evacuation.

So you could take photographs but only with a permit, and that was not likely to be given. Thus any images of wartime London or preparations for war are rare.

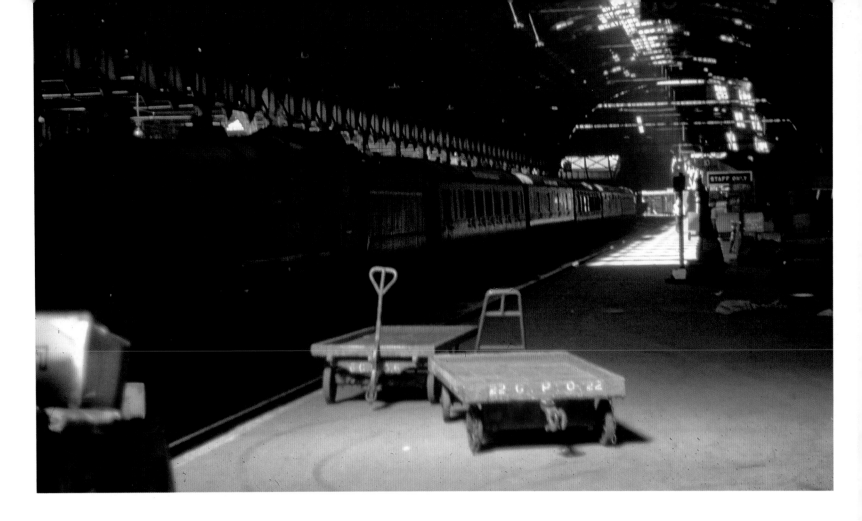

Above: Paddington station is seen here just after VE day in May 1945. Photographed with Kodachrome film, not appreciably faster than Dufaycolor, the sunny day outside the station has made this a study of light and shade. The chocolate and cream coaches seems to have worn the war years well. The locomotive at first defied identification, but on enlargement it is just possible to make out the nameplate, a one word name and with a little detective work: Castle class No. 5071 *Spitfire*. This exposure with the extremes of light and shade has pushed Kodachrome film to its limit.

Right: In 1945, with Marble Arch as a backdrop, an STL bus passes an Emergency Water Supply tank. Loss of water supply whilst fire-fighting was a constant worry due to bomb damage bursting water mains, and numerous water tanks were constructed to provide back-up when these had failed. These iron tanks were everywhere: in parks, streets and even in gardens if they were large enough. The EWS sign told the firemen that an emergency tank was inside or nearby. These EWS reservoirs could also be collapsible, the sides being waterproofed canvas with wooden frames to keep them rigid. The basements of bombed or derelict buildings were also used as EWS reservoirs, after some repairs to improve their water-holding ability.

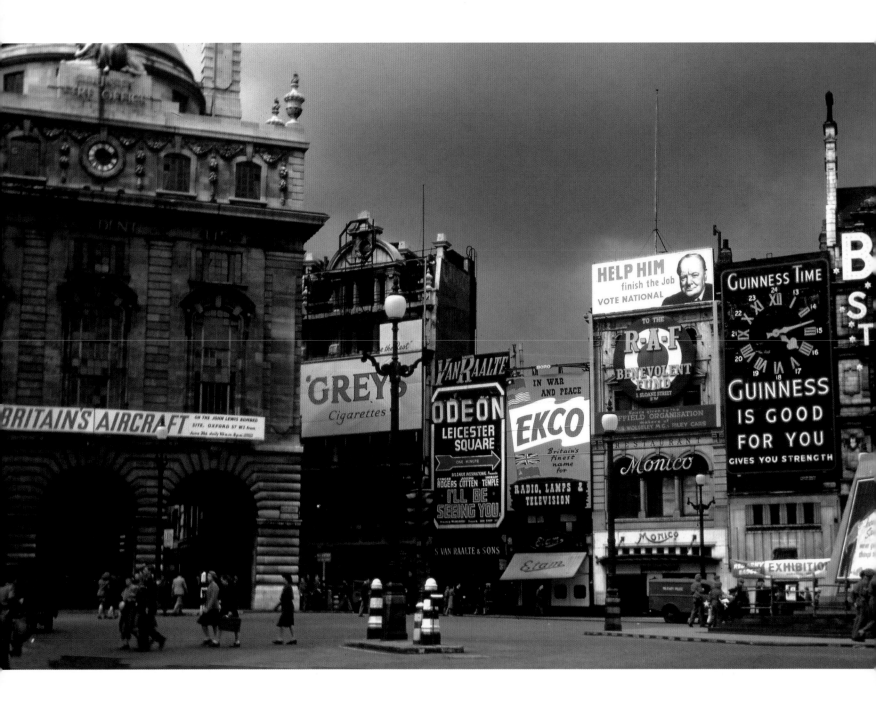

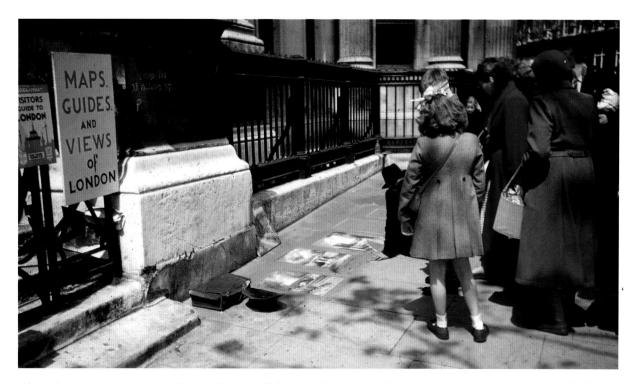

Above: A pavement artist outside the National Gallery's side entrance, St Martins Lane, in 1954. Using chalk he has drawn various scenic images onto the pavement. Nowadays the artist is more likely to tape a chalk drawing to the pavement that can be easily removed rather than making a one-off that will disappear after the first rainfall.

Left: At the end of the war in 1945, Piccadilly Circus was a riot of colour, if not light, for it would not be until 1950 that the lights of Piccadilly would shine again, due to post-war austerity. Glasshouse Street runs to the left to the rear of the County Fire Office building and the boarded-up fountain (the statue of Eros was in storage for the duration of the war) is to the right of the picture, with an appeal from Churchill to vote National – although the first election after the end of the war resulted in Churchill's surprise defeat by Attlee. (The term National Government refers to the caretaker government that had existed since the war ended.)

Almost overlooked is a painted advert for *Dick Whittington* at the Garrick (twice daily) on the building advertising Greys Cigarettes. Mid-1945 is a little early to be thinking about a pantomime, so this may indeed be a reminder of an earlier production – it was certainly performed in 1932 at the Garrick. In the centre of the shot, Ekco are advertising radios, lamps and televisions, but it would be another year until the BBC television service resumed on 7 June 1946. The sign in the middle-left of the photograph is advertisng *I'll Be Seeing You* at the Odeon Leicester Square, starring Ginger Rogers and Joseph Cotton; although the film is not seen often nowadays, the title song became a standard. There is also a display of Britain's Aircraft on the bombed John Lewis site, open daily from 10 a.m. to 8 p.m, and the military police, in a drab green van to the right of the photograph, are keeping an eye on the servicemen loitering around the base of the fountain. An exhibition of Red Army badges is being presented next to Monico's restaurant. There is a lot going on.

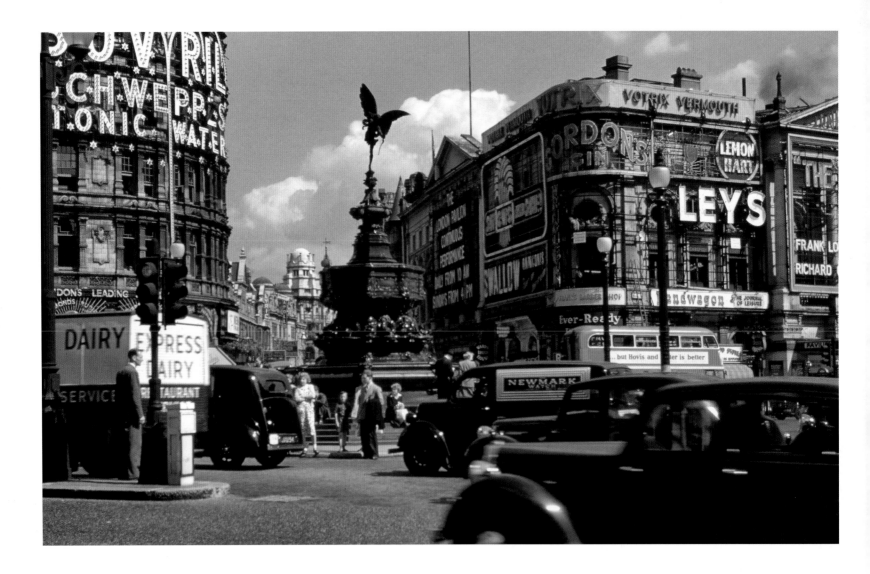

A busy Piccadilly Circus in 1950 by day. *The Sound of Fury*, a black-and-white western, is playing at the Pavilion – a genre that is perhaps a little out of fashion now. In 1950, colour was still a novelty and if a film was in colour the byline 'In Technicolor' would be prominent. Other colour systems were available and several studios used their own, largely to save costs, as Technicolor was an expensive process.

To the left of the picture, the Express Dairy Restaurant Service van is making its rounds of the West End. The Express Dairy was founded in 1864 as the Express County Milk Supply Company, so named because they only used express trains to deliver their milk to London. After several takeovers the company is still trading today as Express Dairies.

The Newmark Watch Company was set up in 1947, with the first watches being delivered in 1950, so this must be one of their first vans (seen here behind the Express Dairy van) out on delivery.

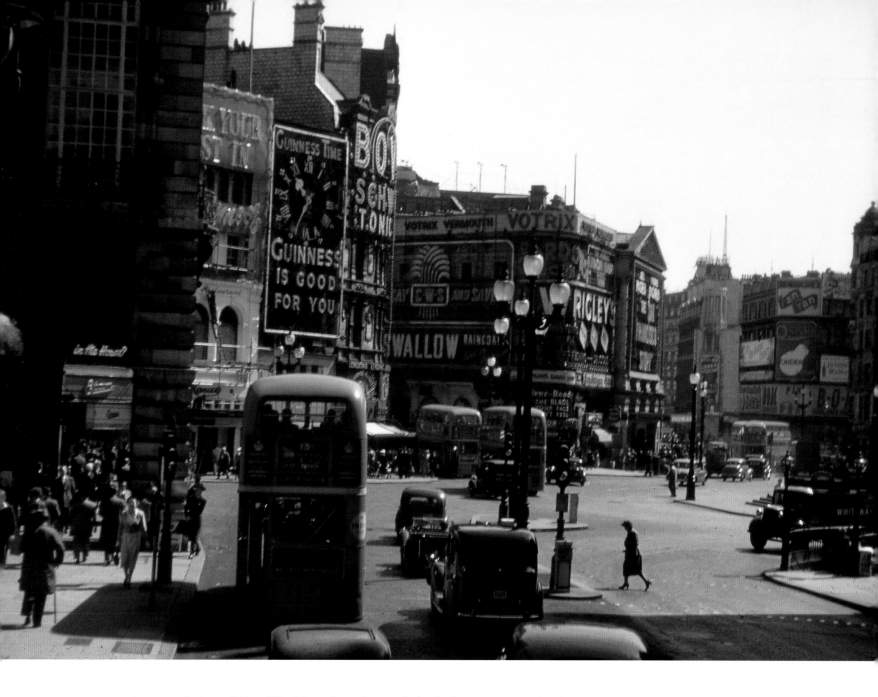

An unusual view of Piccadilly Circus from the top deck of a bus as it approaches the Circus from Regent Street in 1952. *The San Francisco Story* is in continuous performance at the Pavilion, something that doesn't happen now. You could go into the film halfway through a screening and then watch the first half of the film in the next showing after the first half had finished – it could get confusing.

Looking east along Piccadilly at the junction with Old Bond Street in 1956. Apart from a new building on the right-hand side where the yellow van with the Coco-Cola sign on the roof is, this scene is almost unchanged in over half a century. The polka dot dress of the girl crossing the road and the showing of *Rock Around the Clock* (in the far distance at the Pavilion) are portents of a changing world; the glimpse of America that Britain got during the war is starting to make an impact on the culture of the country.

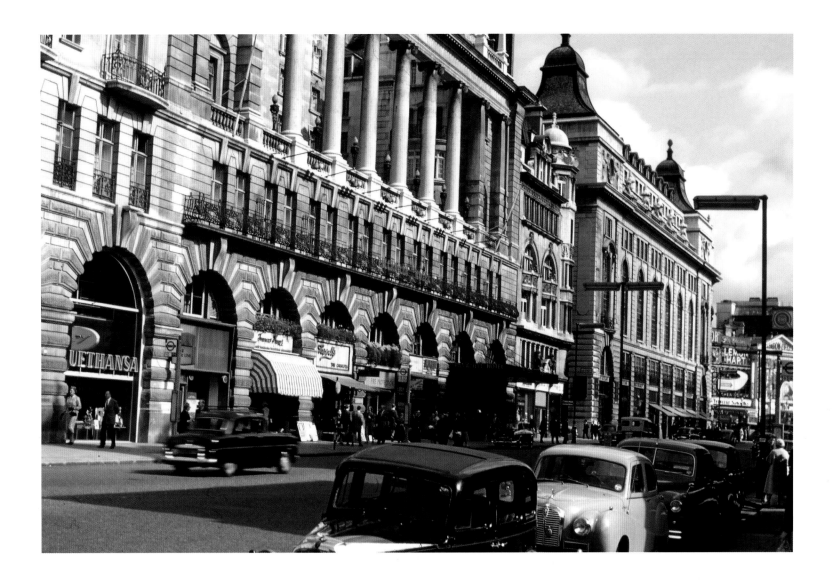

The north side of the east end of Piccadilly in 1958 sees some typical cars of the period parked up. The Piccadilly Hotel, completed in 1908, is now Le Meridien Piccadilly, a 266-bedroom, five-star establishment. Lufthansa, the German national airline, no longer has a presence here. The demography of air travel having changed, it is no longer necessary to have an office in central London, as communication is so much easier now with the internet. However, in 1958, even telephoning was not as easy as it is today. Before the all-numeric codes we use today were established, an alphanumeric system was used, hence the ABC, DEF, etc. on old telephone dials. You dialled the capital letters of the exchange required and then the number of the telephone, the most famous number being WHItehall 1212 (WHI 1212), the number for Scotland Yard. As for phoning abroad, that had to be organised in advance to allow the connection to be set up manually from exchange to exchange and eventually to your intended recipient of the call.

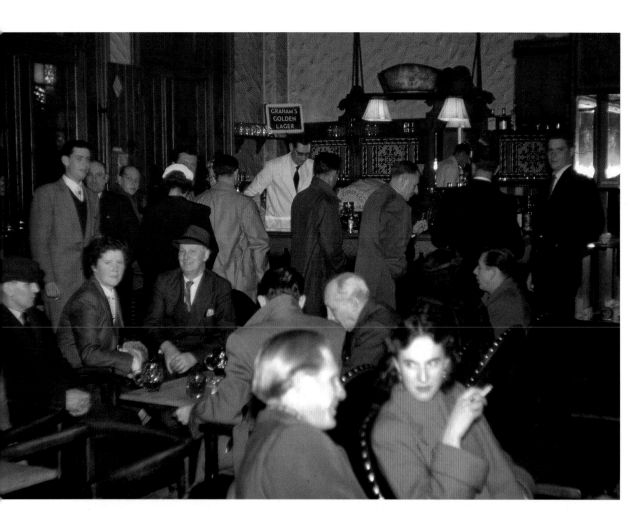

Above: Few tourists ventured into a London pub, and fewer still took a photograph. Here, the interior of an unknown London pub is seen in 1948, decorated in that very British shade of nicotine brown with plenty of dark varnished oak to brighten the proceedings up a little. At first glance it appears to be an ordinary scene, but a lot has changed and pubs are now very different places. The white-coated barman enquires what people would like to drink from what appears to be a rather limited choice: Wm Younger's Ale or Graham's Golden Lager.

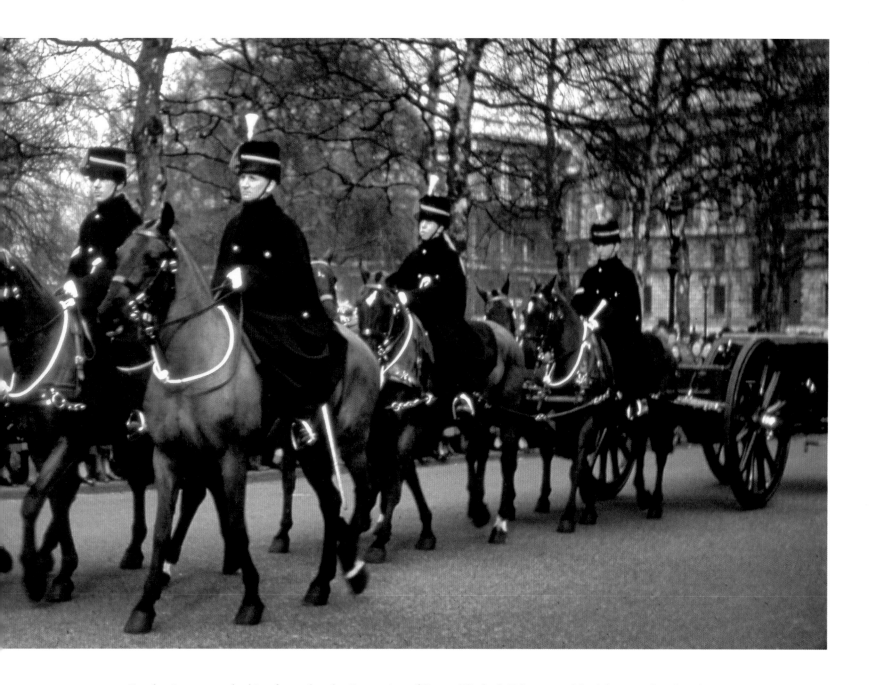

London in 1953 was looking forward to the Coronation of Queen Elizabeth II, but on 24 March her grandmother, Queen Mary, died. She had made it known that in the event of her death the Coronation was not to be postponed. A week later on 31 March the state funeral took place. The coffin was carried on a gun carriage pulled by six members of the Kings Troop. The BBC televised the service as a rehearsal for the Coronation, which took place just over two months later.

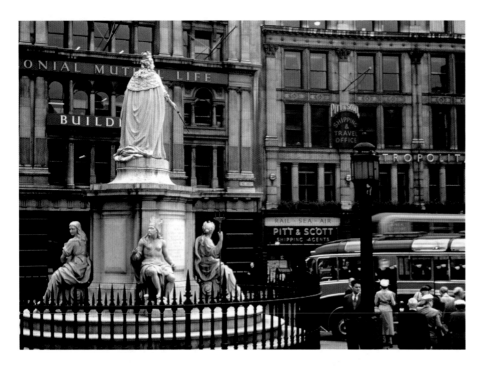

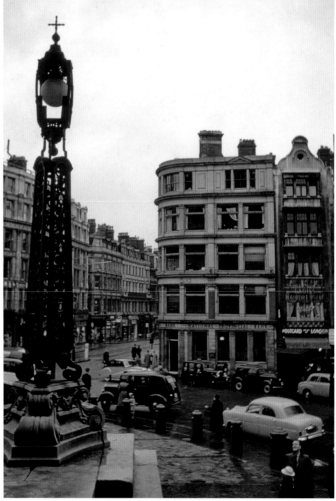

Above: Looking slightly to the left of the image on the right, and a few years earlier, is the other side of St Paul's Churchyard. The road that then passed the cathedral on both sides runs behind the statue of Queen Anne. The businesses seen all reek of empire and a manufacturing base now long gone. The Colonial Mutual Life, an Australian-based financial institution, is now owned by the Commonwealth Bank of Australia. Pitt & Scott are now part of the Pickfords' group and Metropolitan Vickers is now part of the GEC group but the name is no longer used. The buildings have now been cleaned and, although they all still stand, the road just seems so sterile now.

Far right: The Festival of Britain in 1951 was a five-month-long festival with various events being held in cities throughout the country and a former aircraft carrier, HMS *Campania*, circumnavigating Britain from May to October. The best-remembered event, however, was the South Bank Exhibition held between Waterloo Bridge and County Hall on the South Bank of the Thames. The view here is from Hungerford Bridge. The Shot Tower, seen in a previous image, has now had its top gallery removed and radio masts fitted. It would survive the exhibition but would be demolished to allow the Queen Elizabeth Hall to be built, which opened in 1967. In the foreground is Rodney Pier, with the sport and fairground areas of the exhibition visible and the Waterloo Bridge as a backdrop.

Above: Looking towards Ludgate Hill from the steps of St Paul's Cathedral in 1956. The National Provincial Bank is opposite in a building that survived the war but has now given way to an office building with shops at ground level. The bank merged with the Westminster Bank in 1970 to form NatWest. The road to the right-hand side of the picture, St Paul's Churchyard, is now pedestrianised and all traffic has to pass to the left. It is a miserable day and the taxi has just deposited a woman and child. She is now paying the driver, possibly prior to visiting the cathedral.

Right: Selfridges seen across Oxford Street from Balderton Street, *c*. 1959. It is now no longer possible for vehicular traffic to even turn left into Oxford Street as the end of Balderton Street is now pedestrianised. Even in 1956 Oxford Street was so busy that it was a 'left turn only' junction and yellow lines had started to appear. The Midland Bank on the left of the street was taken over by HSBC and is still trading as a bank on the site.

The distinctive statuary above the entrance of Selfridges is the Queen of Time standing on the prow of the Ship of Commerce and was the work of Gilbert Bayes. Selfridge was an innovative showman and only a few months after opening, in 1909, he displayed Louis Bleriot's plane in the store for four days after he made the first powered air crossing of the English Channel in July 1909 (a balloon crossing had been made in 1785). As the exploits of the early aviators was headline news the crowds flocked to the store to see the aircraft – all advantageous when you are trying to entice customers in.

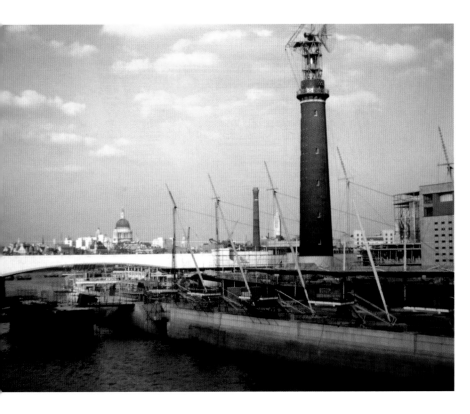

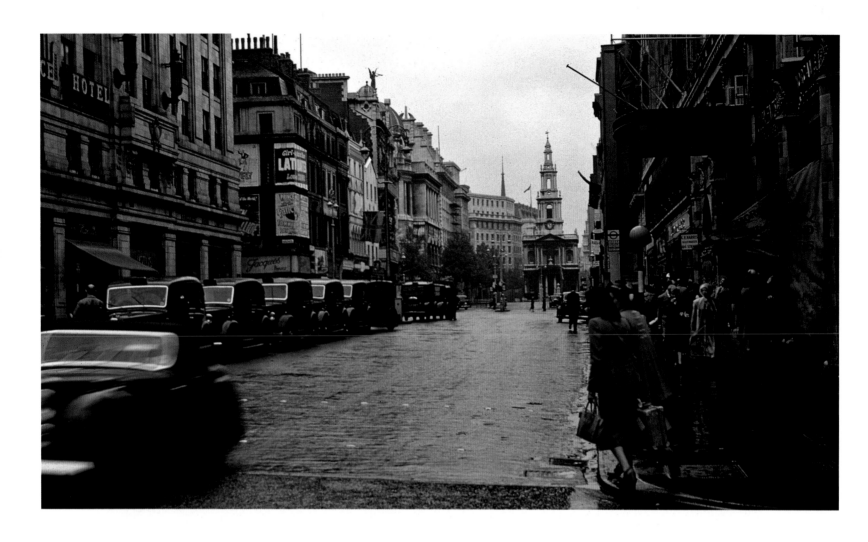

The Strand on an absolutely foul day in 1951. The taxis wait for fares, no doubt more plentiful on a damp, grey day like this. The Gaiety Theatre stands in the middle distance, having been dark (closed) for twelve years; it closed in 1939 and would never reopen. It was demolished in the late 1950s to make way for an office block which in turn has also been demolished. A luxury hotel now fills the site.

Simpsons in the Strand still trades and is one of London's oldest established restaurants, having first opened in 1828, although Simpson was not involved with the business until 1848, only then giving his name to it. It has survived several takeovers in the 180 years it has been trading.

The only splashes of colour are the posters on the building on the left. Tommy Trinder and Pat Kirkwood are starring in *Fancy Free* at the Prince of Wales Theatre and the third annual *Latin Quarter* revue is playing at the London Casino.

Walking towards us is a woman in a new (for 1951) clear plastic mac. The grubby canvas canopy outside Morgan & Ball the shirt makers will be wet and dripping.

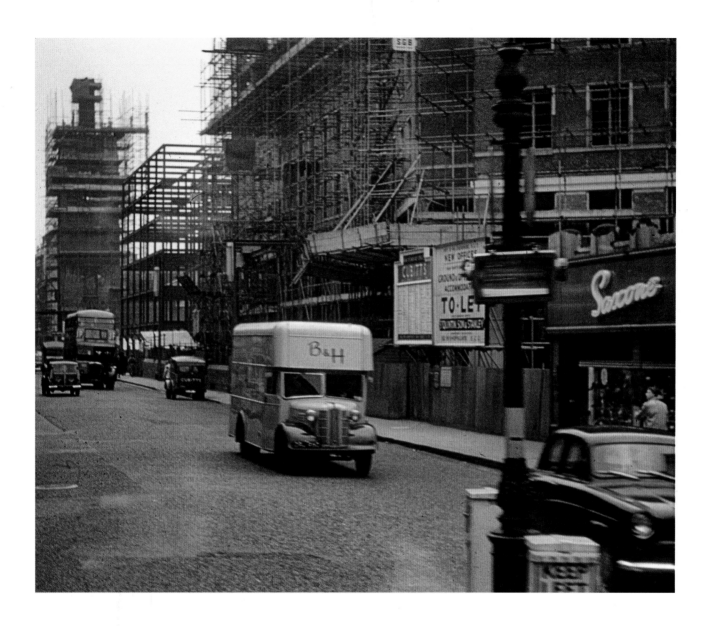

Looking east along the south side of Cheapside, with the tower of St Mary-le-Bow under restoration. Cheapside was heavily bombed during the Second World War, with the bells in the tower of St Mary-le-Bow crashing to the ground. Seen here around 1957, Cheapside is the scene of much rebuilding. Cubitts had the contract to build the new works and their van is parked alongside. They were a long-established London company, having been founded in 1810. After several mergers they were, in 1976, acquired by Tarmac and amalgamated into the Tarmac group. Saxone's shoe shop is also prominent in foreground to the right and was taken over by the Sears group in 1962. After a further series of takeovers, the company name would disappear from the high street in the 1990s.

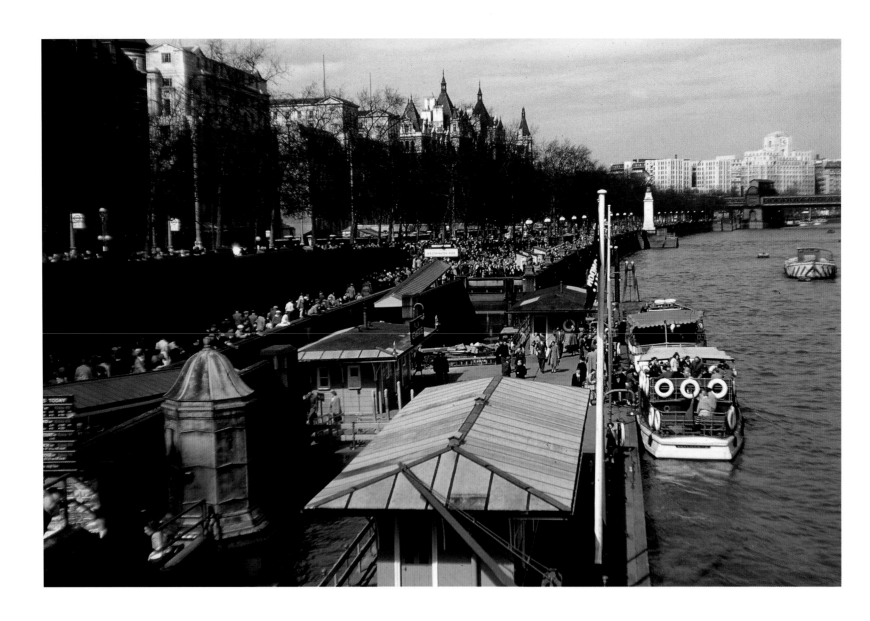

Westminster Pier in 1954 sees summer crowds waiting for river tours on the Thames, which ran to Greenwich or Tower Bridge. The boat in the foreground, *Skylark X*, is one of the Dunkirk little ships that helped the evacuation of Dunkirk in 1940. Built in 1936, she worked on the Thames until being laid up in 1974. Sold on, she worked for a few more years then became a houseboat, sinking at her moorings in 1984.

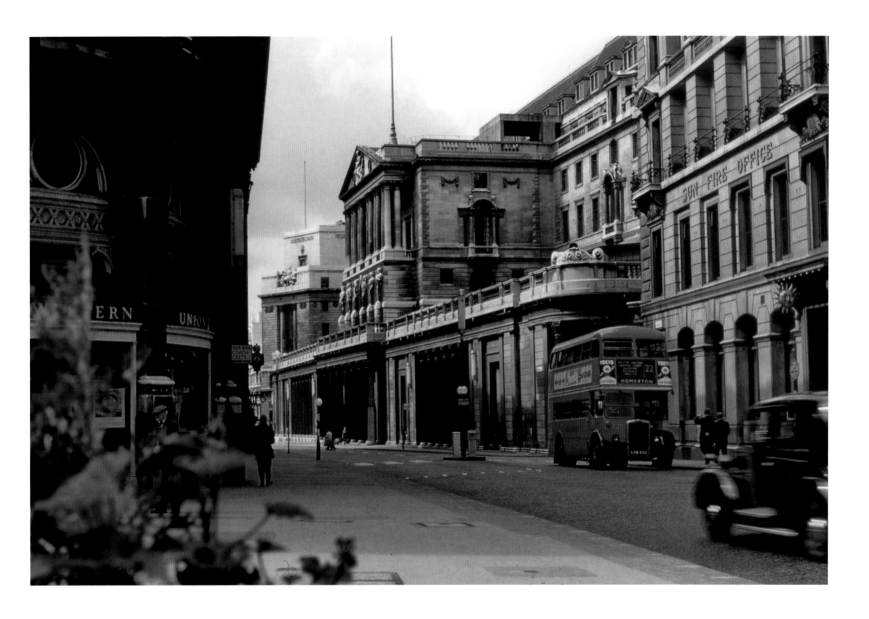

Threadneedle Street, the heart of the financial district, is seen here on a quiet afternoon in 1958. It is just after 1 p.m. and the few people around seem well wrapped up, so it is late in the year. On a weekday this area is busy, but there is hardly any traffic about so it may be a weekend – a bus wends its way on route 22 to Homerton and a taxi heads west, but that's all the traffic there is. The Western Union office on the left is now a food shop catering for the bank and office workers. The imposing bulk of the Bank of England building still stands sentinel, with no windows on the ground floor for reasons of security. The Sun Fire Office building just behind the bus has gone, replaced by a characterless Royal Bank of Scotland office building.

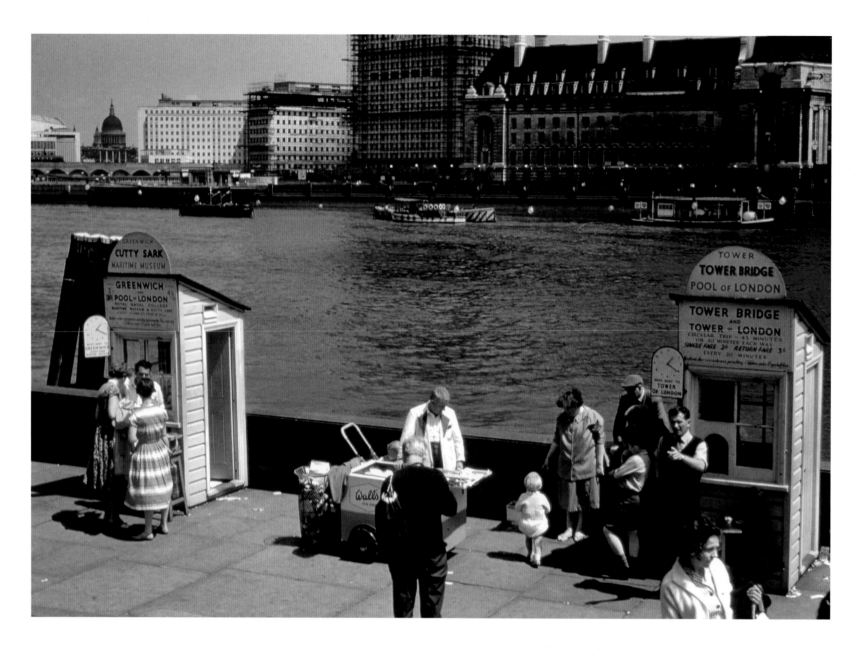

The river tour ticket offices seen on a summer afternoon in 1959. Trips to Greenwich every twenty minutes at 4s 6d return (23p) and trips to the Tower of London every twenty minutes at 3s return (15p). The white-coated Walls ice cream seller will be doing a roaring trade if the sun stays out. Office buildings are being built on part of the site of the Southbank exhibition next to County Hall.

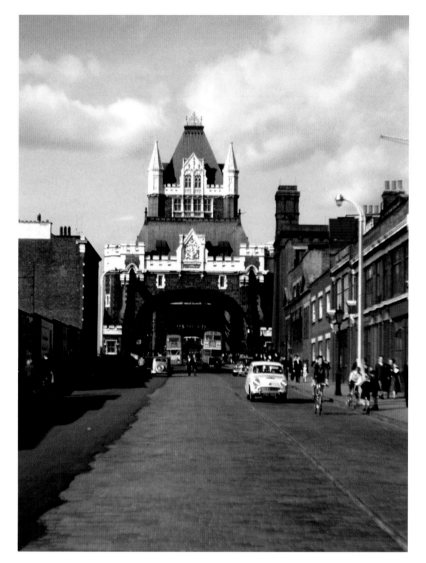

The Tower Bridge southern approach road in 1953. You would be taking your life in your hands if you tried to stand here to take a photograph today. The building on the left remains but only the nearest two buildings on the right survive. The building next to the cyclist has gone, as have all the others towards the bridge, apart from the building with the large brick chimney. This building is the engine house for Tower Bridge, then still in use, with steam- and hydraulic-powered engines to lift the bascules of the bridge. They are now electrically operated, having been converted in 1974.

The entrance to Tower Hill station (named Mark Hill until 1946) is seen here in 1952. This station was closed in 1967 due to increasing passenger numbers and replaced with the present Tower Hill station. This entrance can still be seen today on Byward Street, but it is now part of a bar. Only faint traces remain of the station entrance, although a subway has been reopened to enable pedestrians to cross the busy Byward Street safely.

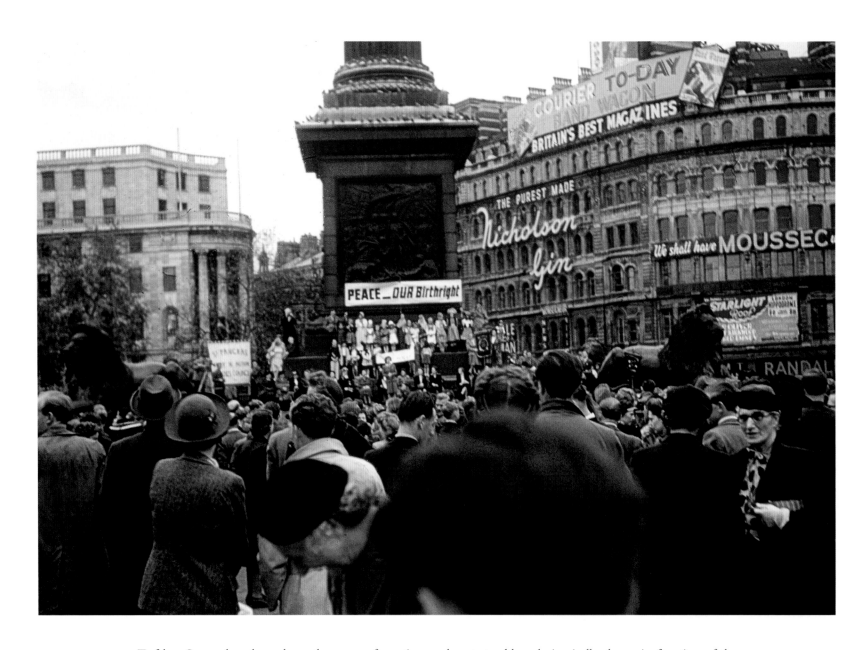

Trafalgar Square has always been the scene of meetings and protests, although, ironically, the main function of the fountains was to prevent meetings turning into riots by breaking up the open space available. Here, in 1948, a large crowd has gathered for what appears to be a peace rally. *The Starlight Roof* at the London Hippodrome, advertised on the building in the background, was presented by Val Parnell, later to become a well-known television producer, possibly best known for *Sunday Night at the London Palladium*, and introduced a 12-year-old Julie Andrews in what was her first West End production.

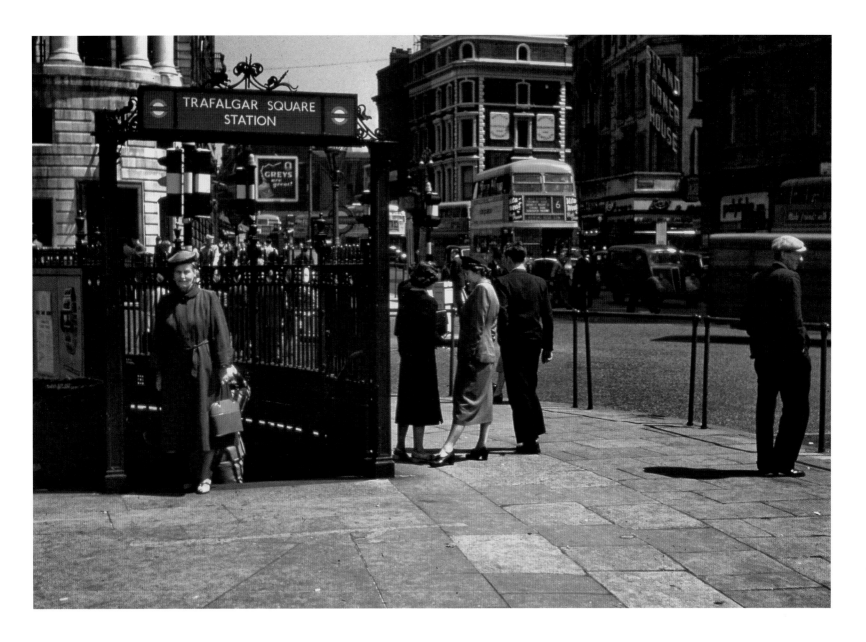

There isn't a Trafalgar Square station on the Bakerloo line now, it was renamed Charing Cross in 1979. In this 1951 photograph we are looking towards The Strand from the south-east corner of Trafalgar Square. The station entrance is still here but The Strand Corner House – one of J. Lyons' corner houses which closed in 1977 – and the building behind it on the south side of The Strand have both been demolished. The advertisement for Greys cigarettes is a wonderful period piece in the background – though its claim that 'Greys are Great' is perhaps not one that would be allowed these days!

It's funny how you only seem to notice the everyday items once they've gone. Wooden tread escalators, such as the ones seen in this photograph, have all been removed from Underground stations, the last being removed from Greenford, a surface station, in early 2014. All the deep stations had the remaining ones removed after the King's Cross fire of 1987.

This is Holborn station in 1947, not many deep stations have just a platform 5, and normally platforms come in twos on the Underground. Platform 5 was for the Aldwych branch. There had once been two platforms for the Aldwych branch, 5 and 6, but due to low traffic levels platform 6 was taken out of use in 1917 and the branch relied on platform 5 until it closed completely in 1994, although the track remains in situ for filming purposes, as it enables Transport for London to allow filming which would otherwise be impossible.

This photograph is really ambitious for slow Kodachrome film – dark and moving down an escalator. I assume flash has been used and the shot is just slightly off being completely sharp but has been included for its art deco interest. There was something magical about the shabby genteelness of the art deco here that has been lost in more modern installations on the Underground in recent years.

Looking towards the Victoria and Albert Museum from Thurlowe Place in 1954, the fenced-off area was originally planned before the Second World War as the site for the National Theatre. This was never built and the site lingered, semi-derelict, until the 1970s when the land was acquired and the Ismali Centre was built, opening in 1985.

The hoardings are covered with advertisements, not all of which are identifiable. The most prominent is for the now defunct *News of the World*. *The Daily Sketch* on the adjacent poster closed and merged with the *Daily Mail* in 1971. Philip Harben, the first TV celebrity chef, is endorsing Cerebos Salt, a brand now owned by Rank Hovis MacDougall. Stork margarine is on the very left-hand-side poster. To the right of the *News of the World* poster, Cole Porter's *Can Can* is playing at the Coliseum. Nescafé coffee was introduced in 1938 but did not become popular until the late 1940s due to the Second World War. It was packed as a staple of American soldiers' rations, which popularised it in Europe. Omo washing powder, although still available in some countries, is no longer sold in Britain.

One of the few images, which even without any information on the slide, can be dated to the day. It is Tuesday, 8 May 1945 and VE Day is being celebrated by vast crowds in the Haymarket, with Coventry Street to the rear of the photographer. Churchill and King George VI wanted Monday 7 May to be VE Day, but in the event, bowing to American wishes, victory was celebrated on 8 May. Despite the war the West End theatres are still pulling in the audiences with their big names. Sir Cedric Hardwick was touring and appearing at the Westminster Theatre on Palace Street in *Yellow Sands*. Having burned down in 2002, the St James's Theatre now stands on the site. Richard Greene, later famous as one of the first stars of Independent Television as *Robin Hood*, was at the Adelphi in *Desert Rats* and Ivor Novello is at the Hippodrome in *Perchance to Dream*. The crowds have flocked to Piccadilly as, after six years of war, they have something to celebrate. However, Britain was almost bankrupt and the end of the war did not mean the end of rationing or austerity – it would be well into the 1950s before rationing finally ended and Britain pulled itself out of the austerity years. The building that has been half completed, Haymarket House, was not finished until 1955 and has been recently refurbished. The two-tone building nearest the camera with the flags displayed has now been replaced with an anonymous office block.

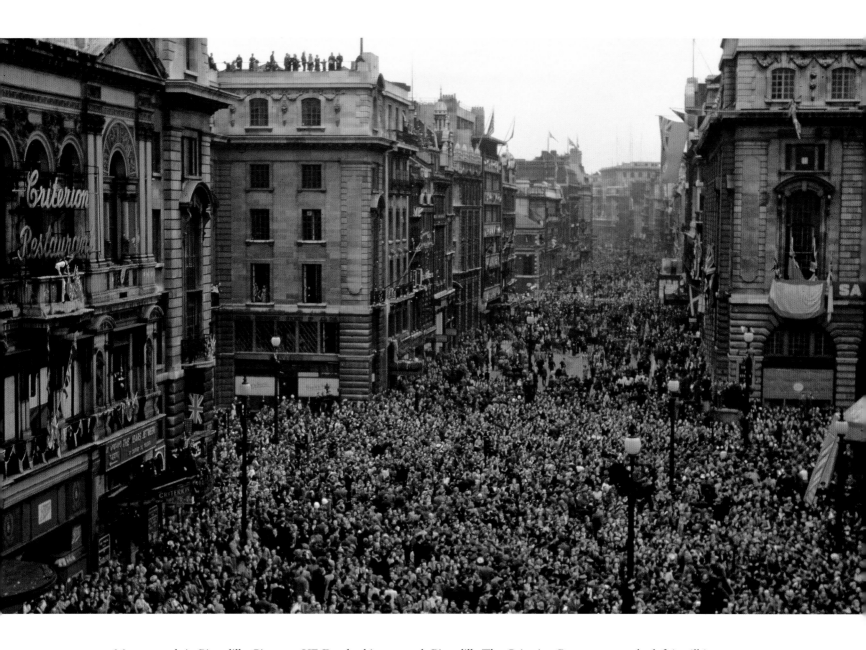

More crowds in Piccadilly Circus on VE Day looking towards Piccadilly. The Criterion Restaurant on the left is still in business, having opened in 1874, and has been host to suffragettes, authors, politicians and film stars over the years. The Criterion Theatre was closed for the duration of the war and was used by the BBC as an underground radio studio. Not all of London is at street level and not all of underground London consists of sewers and trains.

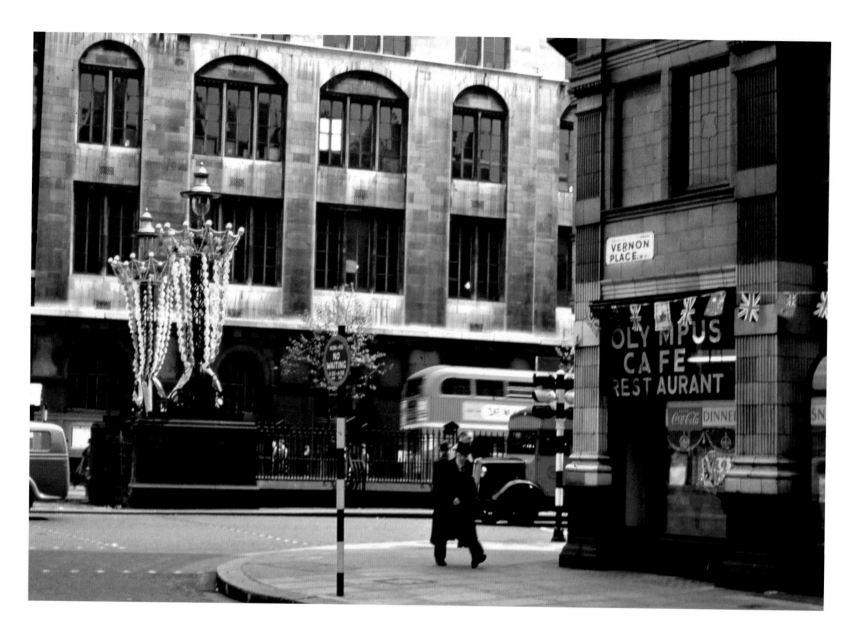

The Olympus Café in Vernon Place off the Kingsway is decorated for the Coronation in 1953. Even away from the busy West End streets, decorations were in place. The blue and yellow ribbons decorate the entrance to the Kingsway tram tunnel, which was by then disused but utilised for the Coronation that year to store buses and coaches in case they were needed for extra transport. The subway is still there but largely disused, although it has had various temporary uses through the years.

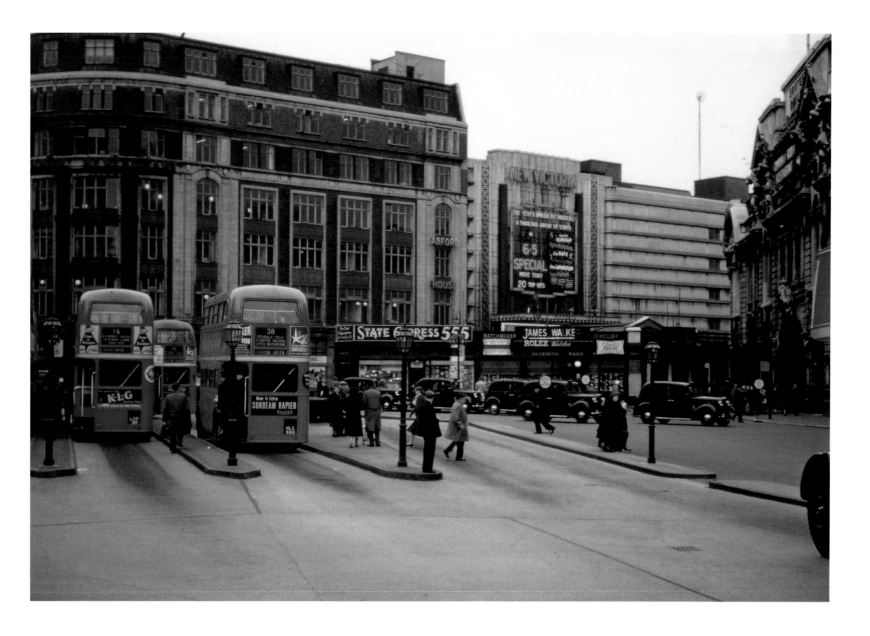

Victoria bus station in 1958. The *6.5 Special* is playing at the New Victoria Theatre – the film version of the popular BBC television music show. Films were last shown here in 1975 and it is now exclusively a theatre. The taxis wait on a row for fares from Victoria railway station, which is behind the photographer. This scene has changed a lot. The building to the left of the theatre, Abford House, has gone and has been replaced with a new Abford House, a nine-storey office building completed in 2009. The bus station later had an all-over roof which was removed in 2003. The row of shops in front of the theatre have gone completely and it is now just open space.

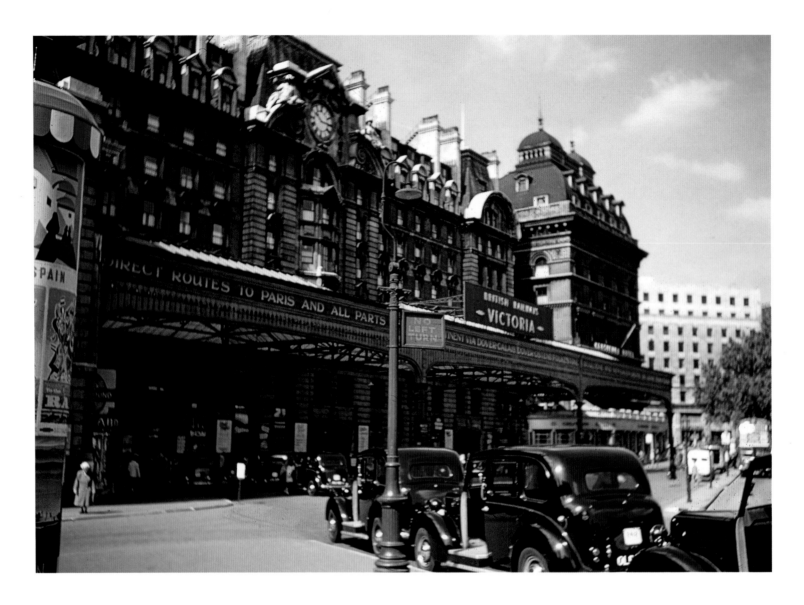

Victoria station looking in the opposite direction a few years earlier in 1955. The taxis are omnipresent. The station building has been cleaned since this image was taken and now only advertises itself as 'London Victoria Station'; no longer does it proclaim 'Direct Routes to Paris and all parts of the Continent via Dover – Calais' etc.

In the 1950s foreign travel was much more of an adventure than it seems to be today. The Continent was exotic; all those French pavement cafés and Italian cathedrals were only a dream to many in Britain. Despite this there are posters advertising 'To the Continent by Rail', so there was a market for European travel for those who could afford it.

The boat train awaits passengers in the station; pay the taxi driver and the porter will carry your trunk to the train. Travel may seem to have lost its magic now but perhaps there never was any to begin with.

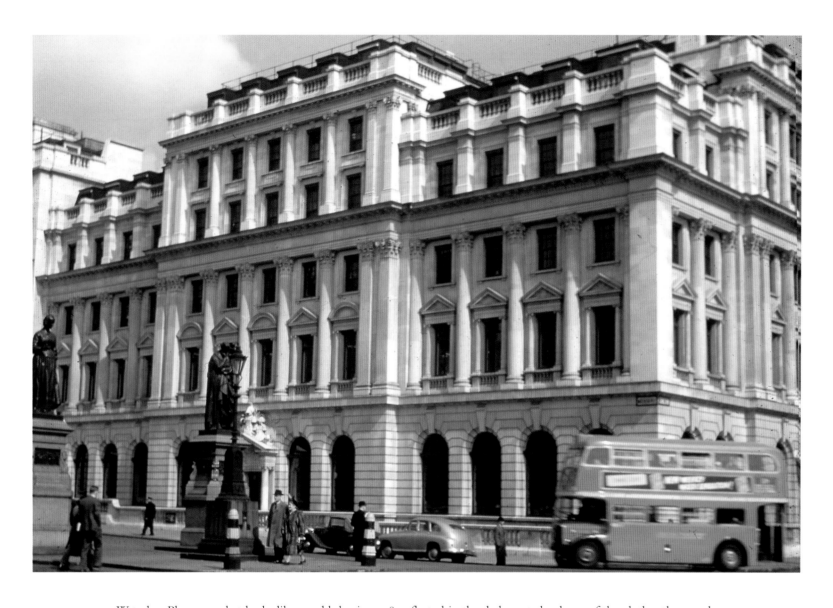

Waterloo Place on what looks like a cold day in 1948, reflected in the drab, muted colours of the clothes the people are wearing. Very little has changed in this picture in over sixty-five years. The two statues are of Florence Nightingale and Lord Herbert of Lea, who was Secretary of War during the Crimean War. They stand in front of the Crimean War Memorial, which had been moved in 1914 to accommodate them. A bus turns into Waterloo Place just fast enough to blur slightly on the Kodachrome slide. The woman in the fashionable fur coat and feathered hat is passing a lamp standard on a granite base that has the initials WR IV on it. Not many lamp standards survive from the pre-Victorian era; this example dates from 1830–35.

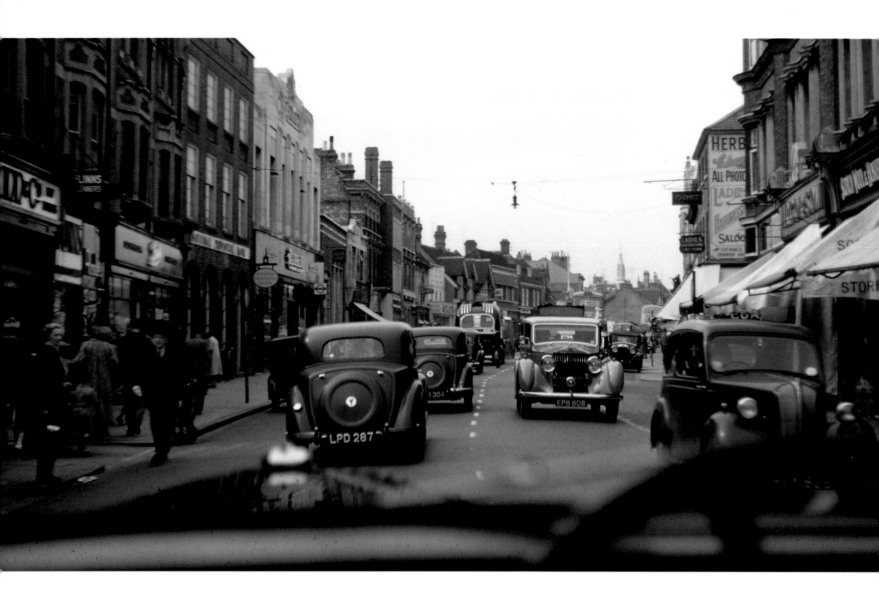

The very ordinariness of this shot is what makes it so interesting. It is a typical busy London suburban street scene in 1951. Dunn & Co., Boots, the National Provincial Bank, Burtons the tailors, ABC tea room and the Scotch Wool and Hosiery stores are among the identifiable businesses. A Rolls-Royce heads towards the camera with what looks to be a roof advert for Gomm's Fuels – there does not appear to be anything following that could carry a sign like that and it is almost central on the roof of the Rolls-Royce. After the war Rolls-Royces were frequently used for commercial purposes and as breakdown vehicles (among other uses), as their values were far less than they are today. Petrol rationing, which had only finished the previous year, was possibly one of the reasons that large cars were cheaper then than you may consider they ought to have been.

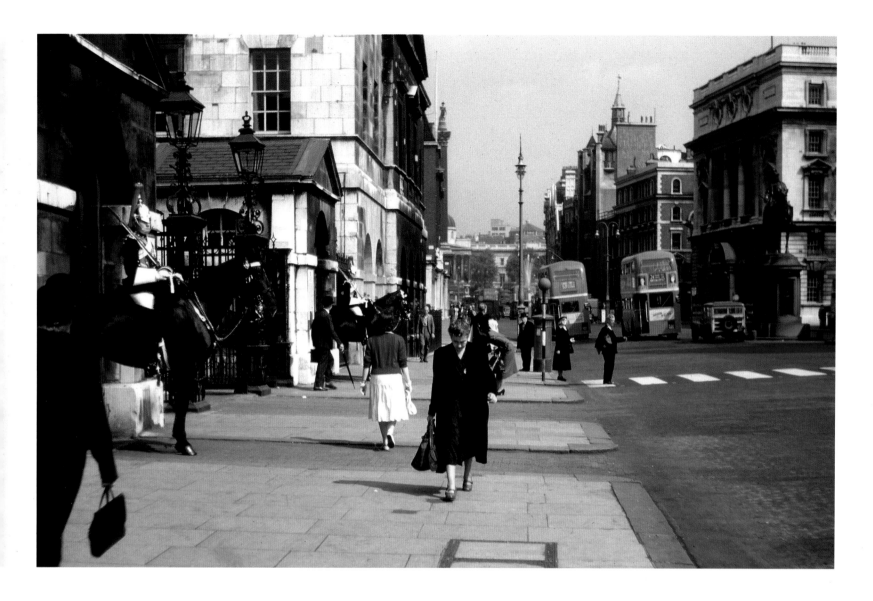

Whitehall, the centre of government, runs from Trafalgar Square to Parliament Square. Here, looking towards Trafalgar Square, a large 1930s woody shooting brake, possibly a Rolls-Royce, makes its way along Whitehall. Not many of these survive, as the wood – normally ash – rots in the British climate unless regularly varnished. Some of these were lucky to survive a decade; therefore, even by the 1950s, they were rare birds on London's streets.

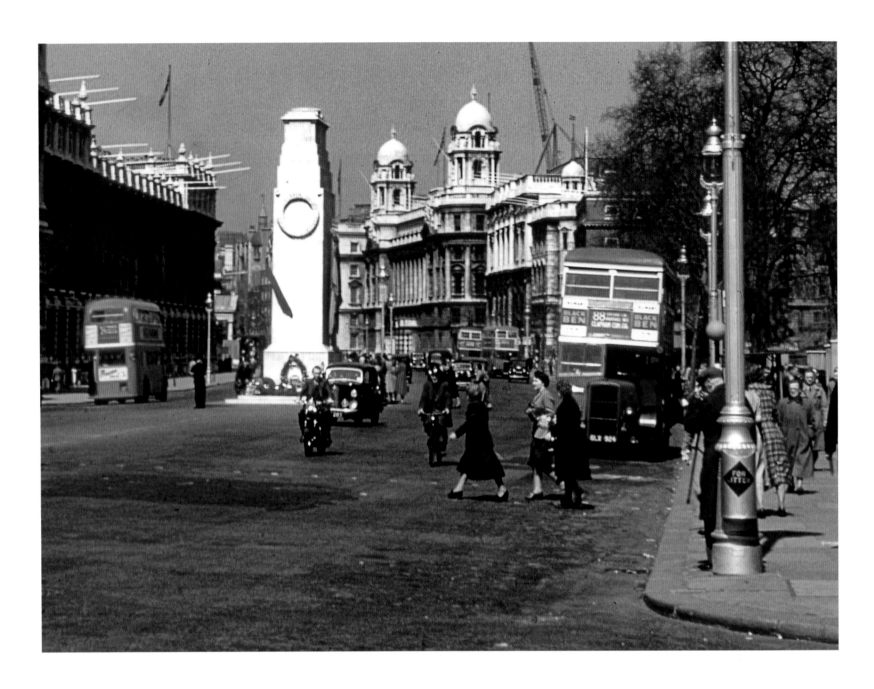

Whitehall a few years earlier in 1948 sees the precursor to the zebra crossing in use. Marked only by Belisha beacons and studs in the road, it was all too easy to miss the crossings when driving. It is now obvious to see why white and black markings were later introduced, as it gave the crossing much more prominence to road users. Behind the crossing, the bus liveries are changing from white-windowed top decks to almost the all-over red that we are familiar with today.

VINTAGE LONDON

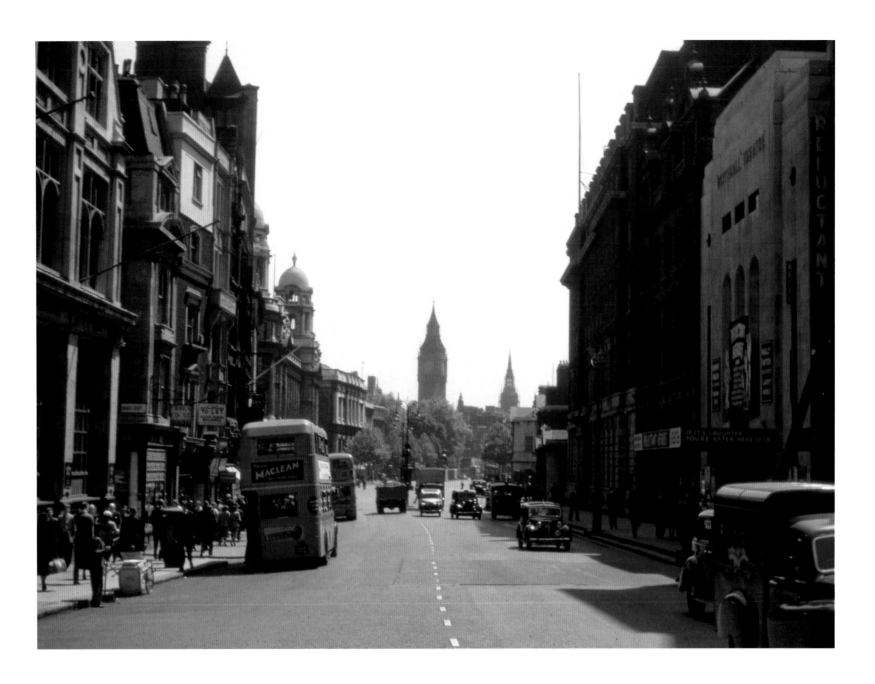

Another view of Whitehall in 1952 looking towards Parliament Square, with *Reluctant Heroes* playing at the Whitehall Theatre. The first of the Whitehall Farces, it ran for nearly four years with 1,610 performances, finishing in July 1954. The adverts on the rear of the bus are for still familiar products: Macleans toothpaste and Pirelli tyres. 'Did You Maclean Your Teeth Today?' was, even by 1952, a well-known slogan, having been in use since the 1930s.

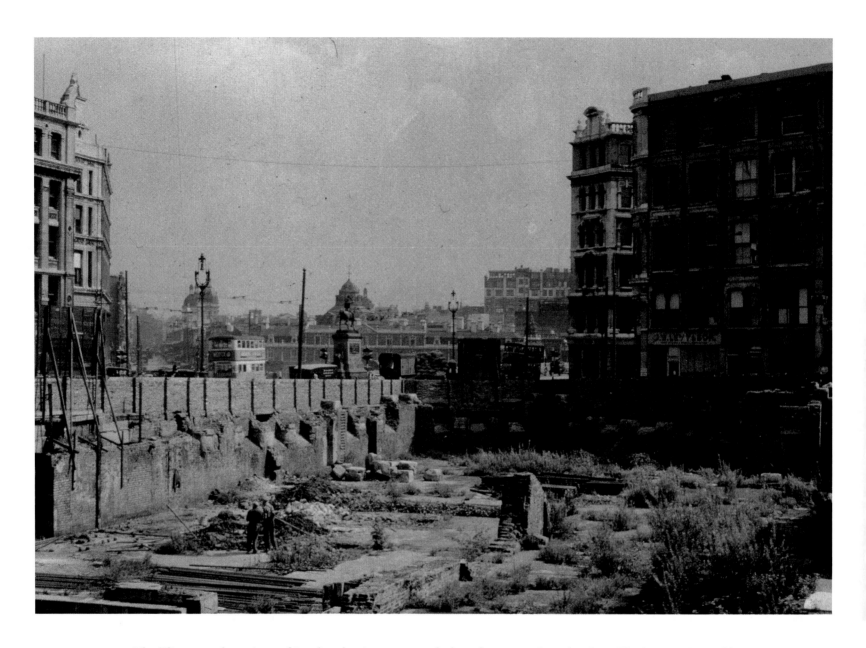

The Blitz opened up views of London that in some cases had not been seen since the Great Fire in 1666. It would be decades before some of the sites were redeveloped. Here, looking from Fetter Lane towards Smithfield in 1946, a vista has opened up that shows a whole swathe of London that is unavailable to view today; indeed, most of what you can see has been demolished and replaced in the years since this was taken. In the middle distance the statue is that of Prince Albert in Holborn Circus. To try and get your bearings in this image, Charterhouse Street is straight ahead, with Holborn Viaduct unseen to the right, both running away from the photographer.

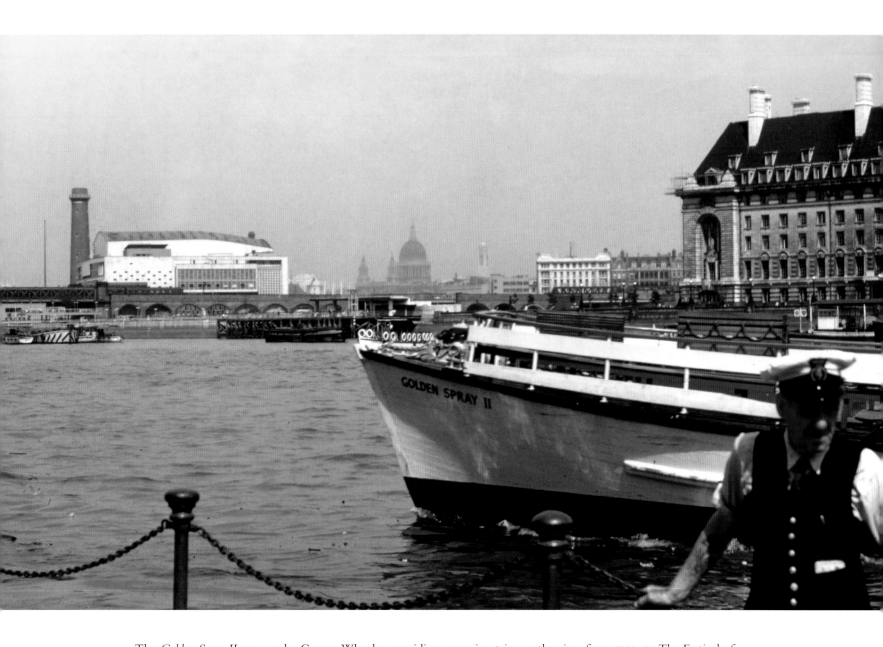

The *Golden Spray II* was run by George Wheeler, providing excursion trips on the river from 1953–71. The Festival of Britain has been over for a few years but the Shot Tower still stands (and would do until 1967 when it was demolished to build the Queen Elizabeth Hall). St Paul's Cathedral and the OXO Tower can be seen in the distance. The OXO Tower was built in 1928–29 and was to include illuminated advertisements. When permission for these was not granted the design was altered to include four sets of three vertical windows, each of which just 'happened' to be in the shapes of a circle, a cross and a circle spelling out OXO.

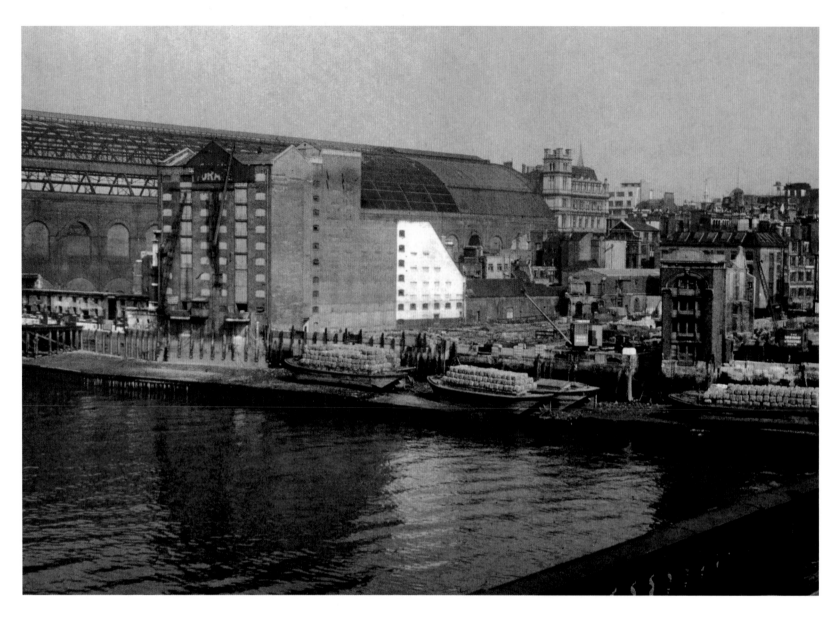

The hulk of Cannon Street station in all its blackened majesty is photographed from London Bridge on a Dufaycolor transparency in 1946. The glass from the roof had been removed for the war, but the factory where it was being stored was bombed and the glass destroyed. The area nearby the station has suffered damage and some clearance is taking place; this was the London that tourists seldom saw. Americans had not yet started to travel for pleasure again to Europe after the war, due to restrictions placed on them by the American State Department, and they had to get special clearance because of any extra burden on an already overstretched infrastructure. As can be seen here, there was a long way to go before London was back to some sort of normality.